NEWPORTRAIT

To Joan W. Coakham
and the memory of Gerald F. Briggs

NEWPORTRAIT

JOHN BRIGGS

Foreword by Alan Roderick

SEREN

Seren is the book imprint of
Poetry Wales Press Ltd
Nolton Street, Bridgend, Wales
www.seren-books.com

ISBN 978-1-85411-479-2

A CIP record for this title is available from
the British Library

The publisher works with the financial assistance
of the Welsh Books Council

Printed by
HWS Print, Tonypandy, Wales

Contents

Foreword

One of the photographs in *Newportrait*, this striking collection of images from Wales's newest and third largest city, shows a Welsh Open Golf marshal at the Celtic Manor holding aloft a sign proclaiming 'NO CAMERAS'. Luckily for us all, John Briggs chose to ignore that injunction and deploy his camera to great effect, bringing a fresh eye to many aspects of Newport life. The 'usual suspects' are all here, of course – City icons like the Transporter Bridge, St. Woolos Cathedral and Tredegar House, the Chartist mural, the Doctor Who Tardis phone box on Chepstow Road and the Art College, surrounded by scaffolding and still awaiting its saviour, but they are balanced by new additions to the cityscape such as the Riverfront Theatre and Arts Centre, the Velodrome, the new upstairs window in Newport Market, the Newport Ship, the Pedestrian Footbridge, the Wetlands Reserve, those symbols of a 'new' Newport. John is fearless in his pursuit of the perfect photograph, pointing his lens where other photographers would fear to click a shutter. It takes a brave human being to confront a High Street hen party in full swing or take photographs of a ghostly-looking and strangely empty Old Green Crossing at night.

He is also a perfectionist. Not for him the quick fix of the digital camera or mobile phone, he is a craftsman of the old school who still takes and develops his own photos in the time honoured way using a 'proper' camera. He also possesses the happy knack of making the things he photographs look better in his black and white universe than they do in reality. *Newportrait* simultaneously looks forward and back. Some of its images are already slipping into the realms of Newport folklore – Frankie, the little singer with the hat and the big voice, serenading all and sundry from his vantage point on John Frost Square, an LG factory bus stop, the much missed imploding Newport Clock. Others recall a vanished world. The Cattle Market established in 1844, once thriving businesses that disappeared on their owners' retirement, such as Phillips' Gents Outfitters and Traces' Paint and Wallpaper shop in Upper Dock Street will soon be a distant memory but *Newportrait* also depicts a city still in flux, changing by the day, teetering on the brink of a new beginning as it waits for the promised redevelopment to become reality. The pictures of the construction workers building the new city and the hoardings advertising the forthcoming university development along the banks of the river show the hopes invested in the future, credit crunch notwithstanding. John has an eye for the telling detail, the strange juxtaposition such as the cross suspended above the former scrap dealers in Church Street. Bleak at times, but always challenging, his photographs are of interest to the camera buff and the casual observer alike. His telling, occasionally startlingly atmospheric compositions – the 'dark, satanic mills imagery' of Llanwern Steelworks is just one example – draw the viewer into his world. There is a crispness, a clarity and a sharpness to these photographs that will delight and enthuse those lucky enough to view them. Some of John's evocative black and white photographs recall Newport's industrial past from the abandoned Whitehead Steelworks on Mendalgief Road to the Malthouse in the

Old Town Dock, a reminder that the City was once home to a thriving brewing industry.

But it is not just buildings that *Newportrait* celebrates. The City's citizens, old and young, are captured at work and at play and come alive as they go about their daily business. The lady about to feed a strangely serene looking pigeon, the market traders soon to be evicted from their home on the upstairs floor, casualties of 'progress', the young people only too pleased to pose with their mates, the football and rugby supporters desperate for success, a packed 'Weston' boat - all are immortalised under the steady gaze of John's all seeing camera eye.

And it is at this point I feel I should declare a vested interest. When I wrote *The Pubs of Newport* I conceived the idea of illustrating it with black and white photographs. Who better to take the photographs than John Briggs who had already successfully collaborated with me to great effect on my other books: *Johnny! The Story of the Happy Warrior, The Newport Kaleidoscope* and *Newport Rugby Greats*. After all, when you already know the best, why look elsewhere? Since those days, John has gone from strength to strength and become an author in his own right. *Newportrait* is his third book to date. Most people would be more than satisfied with compiling a photographic record of one Welsh city, but not John who has two previous books on the Cardiff Docklands – *Before the Deluge* and *Taken in Time* – under his belt, a remarkable achievement, all the more remarkable when it is remembered that he is neither a Newport 'boy' by birth or a native of Cardiff or anywhere else in the British Isles for that matter, but was born and raised thousands of miles away in St Paul, Minnesota. An American long resident in South Wales, John has done his adopted country proud with this affectionate portrait of the place he now calls 'home'. What a pity it is that he was not around to document the last great upheaval in Newport's history in the 1960s when so much that was valuable about old Newport vanished forever. If Newport City Council has a glimmer of sense, it will designate the Man from Minnesota as the Official City Photographer with immediate effect. *Newportrait* leaves you wanting more than the one hundred or so images found within its pages. One man's view of Newport, warts and all, it is a triumph and deserves to find a place in the home of everyone who cares about Newport. I commend it to you

Alan Roderick, Newport/Casnewydd, September 2008

Introduction

The images in this collection are the photographic response to what I see as the need for a contemporary look at Newport, Wales' newest city, preferably by a local inhabitant with a keen eye and a camera. There hasn't really been anything of this kind since the excellent 1980s 'Newport Survey' series by student documentary photographers and staff from Newport's famed School of Documentary Photography. That was some twenty-five years ago. In that multi-volume series of gritty black and white images, each dealing with a separate aspect of the life of the *town* of Newport as it was then, the place was described at one point, with bleak photographic evidence in support, as a 'no man's land, a no plans land'. An uncomplimentary appraisal, though perhaps not undeserved at the time. Difficult to imagine now, when, to even the most casual onlooker, a glance in any direction can't fail to note the massive facelift that Newport is undergoing. Renewal, investment and urban planning on a scale not seen since the 1960s are doing their best to give the city a new lease of life, removing some fifty-year old brutal concrete eyesores into the bargain. Projects extend to the year 2020 but the rush is on to complete several landmark schemes by 2010. That's when the Ryder Cup, the world's most prestigious international golf tournament, comes to town with its attendant international media caravan. Newport wants to be ready to bask in the brief but intense spotlight it will bring. Many pristine structures are already in place – a new arts centre, schools, roads and bridges, riverside apartments and housing projects, business parks and offices, public art,

out-of-town shopping precincts, sports facilities including a world-class velodrome and, to be sure, the new golf course ready to host the Ryder Cup on the outskirts of the city. Other parts of the grand plan, unfortunately, have been brought to a temporary standstill by the recent economic downturn. The centrepiece of Newport's redevelopment, a monumental shopping, leisure and hotel complex, is, at the time of writing, in need of a new developer to help fund it. Nonetheless, plans for a new railway station have not been sidetracked and construction of a new city-centre university campus is on target for completion.

Not surprisingly there has been a flood of local council and developers' glossy publicity brochures. Artists' impressions and billboard-sized computer-generated images portray Newport as the new Welsh urban phenomenon, its regeneration being given vital impetus by the conferral upon it of City status in 2002. And to cater for the past, a plethora of picture books reminding us of the town's former glories, mainly collections of old photographs, feeds the appetite for nostalgia. As an inhabitant come from foreign parts, as many Newportonians are, I pore over my own volumes of 'Newport Yesteryear' fascinated by the background and history of my adopted home-town. I should add that my personal involvement in Newport goes back not just to my own arrival in the 1970s but, indirectly, to the 1940s. It was during the Second World War for a few months beginning in August 1942 that my father was stationed at the American army camp at Malpas. Like me, the soldiers were impressed by

Newport's setting in the 'beautiful hills of South Wales' and thankful for the hospitable nature of Newport people. The vagaries of the weather, often a factor to contend with as I photograph Newport's streets, did not escape their attention either. The camp at Malpas was so often wet and muddy that their adaptation of 'Deep in the Heart of Texas' to 'Deep in the Mud of Malpas' was their favourite ditty. The Newport/Welsh climate notwithstanding, as a photographer I have always been convinced that this town-now-a-city is really worthy of exploration with a camera, lots of time and plenty of film. The present collection covers Newport's march through time over the last decade or so, with a few images going back to the Seventies.

I will admit to my near-obsessive attachment to the icons of Newport's past. The new city crams impressive vestiges of its history into a small space. For a start it can claim to have a Norman castle, part-Norman cathedral and the remains of a fifteenth century ship all within half a mile of each other. Then, on its outskirts, there's the truly glorious, beautifully refurbished eighteenth century Tredegar House full of the ancestral treasures of the Morgans, that richest and most extravagant of Welsh aristocratic families. Statues and mosaics in the city centre celebrate the violent climax of the Chartist Movement in front of the Westgate Hotel. Judging by the number of intact Victorian and Edwardian facades that grace its streets from the docks to the city centre, it wasn't just an industrial town that was born as Newport boomed in the nineteenth and twentieth centuries, but an architecturally stylish one as well. Industrial and architectural style blend to perfection in the form of the Transporter Bridge. But now that Newport's traditional industrial and maritime base has fallen away in the twenty-first century, as in the rest of post-industrial south Wales, the time has come to pay homage to those edifices many of which are no longer present. In recent times, a remarkable range of large-scale public works of art have been commissioned to celebrate Newport's industrial, maritime, literary, religious and political legacies. It is now also time to preserve in photographic form the vanished traditional industries, the markets, the docks, the old streets, shops and pubs of the city. For it will not be long before new structures, those of contemporary industry, commerce and infrastructure, shopping, leisure, cultural and educational facilities, take their place in our minds as well as in their physical form. Thankfully many older city streets, estates and traditional neighbourhoods will continue to determine the city's varied character when all of the hullabaloo over the new build has died down. But the balance between old and new structures that at this very moment show up, as never before, the contrast between the city's past and its future, gives Newport, in my opinion, a uniqueness among Welsh cities – a uniqueness that will become better-appreciated in years to come. Here is a phenomenon that clearly requires present-day photographic attention.

In addition to its past, especially to its time-honoured urban landscape, I feel another equally strong attraction. This is to Newport's human makeup, to the city's everyday people who don't figure in glossy brochures or nostalgia books but who determine, as they always will, the remarkably complex nature of this city. Demographically, Newport embraces a dizzying mix of people. Its neighbourhoods abound not just with Anglo-

Welsh inhabitants but also with Asian, African, Middle Eastern and East European residents, their languages and cultures, their shops and takeaways, their cultural centres and churches. Whether in the city or on its estates these neighbourhoods seem to me to remain impressively intact and have a real community feel to them. Being out and about with a camera in Newport is as challenging as it is exhilarating, there's so much human activity going on around you. Being without a camera makes you think often of missed opportunities. As a photographer who has frequently been on Newport's streets for over a decade, my desire to put together a composite picture of Newport's people in their changing urban environment has never diminished. Quite the contrary.

My photographic affinity for Newport then, is nurtured by different sources – by the evidence I see of its past, what I see taking shape for the future and what I've come to know of Newport and its people since my arrival here almost thirty-five years ago. It's a very different place to what it was when I first arrived in the 1970s. And no doubt very different to the thirty years before that, when my father found himself stationed at Malpas Camp.

But expressing in visual form what takes place over time is what motivates many photographers, especially one such as myself who cut their teeth on photojournalism back in the 1960s. To me, photography is a beguiling journey, or a series of journeys, in the real world of never-ending change. Newport gives me that on my doorstep.

Having said that, I can't claim to do justice to all of what I've just mentioned above in a book of around 100 photographs. So let this collection be considered a sort of Newport sampler at this significant stage in its career.

With that in mind, and for those who are already familiar Newport, I hope that viewing this collection might give rise to an extended or at least reaffirmed appreciation of the city they know. For those who know Newport very little or not at all, I hope that this collection might arouse some measure of interest, curiosity, surprise or whatever other positive feelings might be evoked by these images of Wales' newest city as it evolves into the twenty-first century.

John Briggs, July 2009

City People (1)

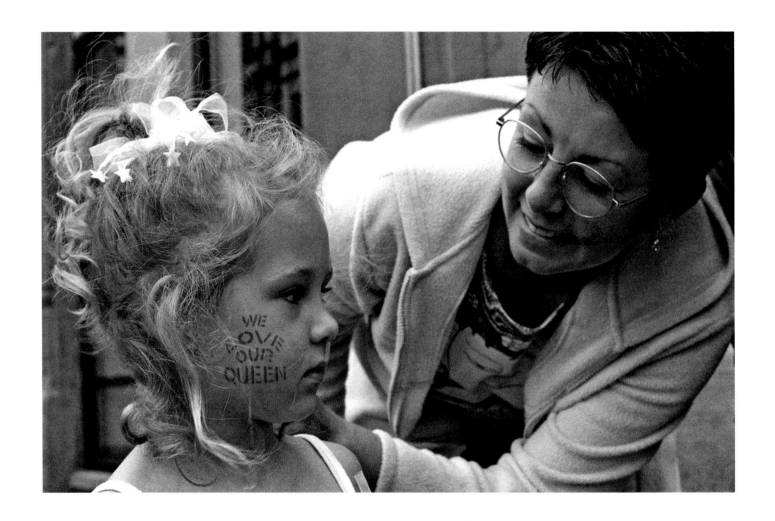

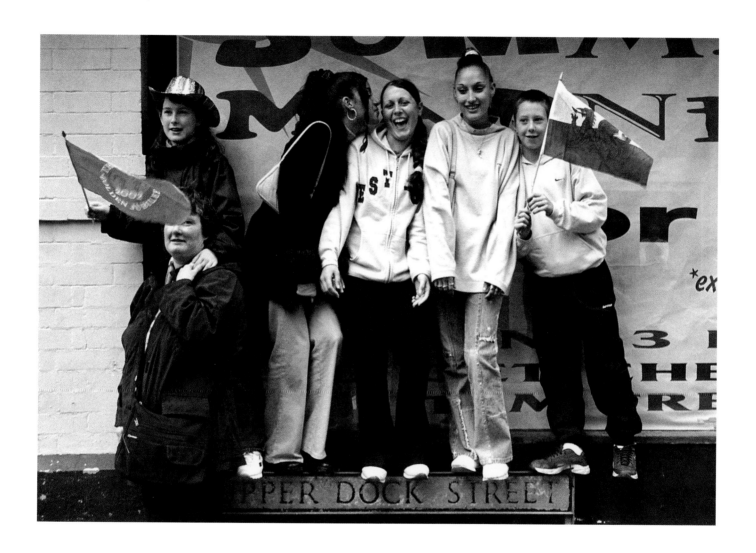

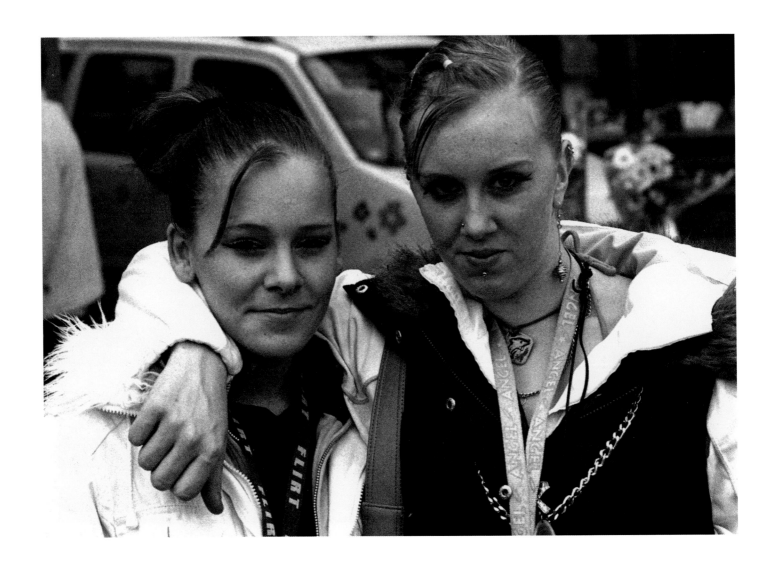

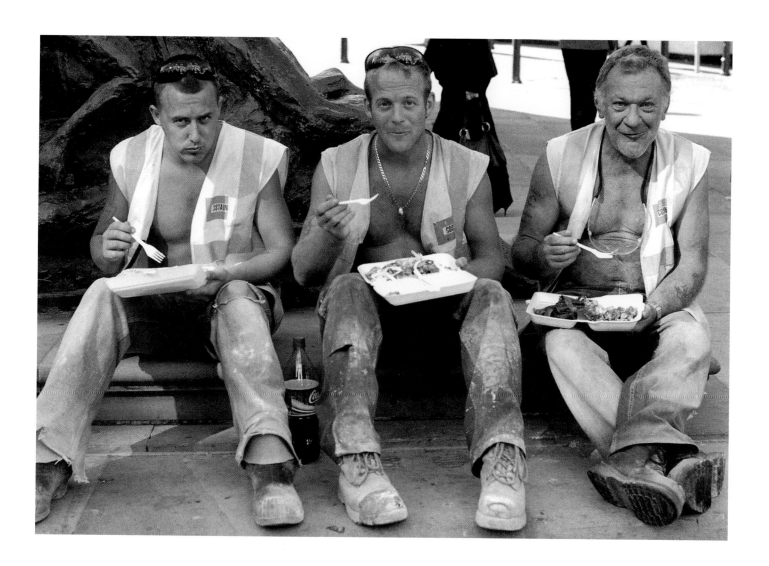

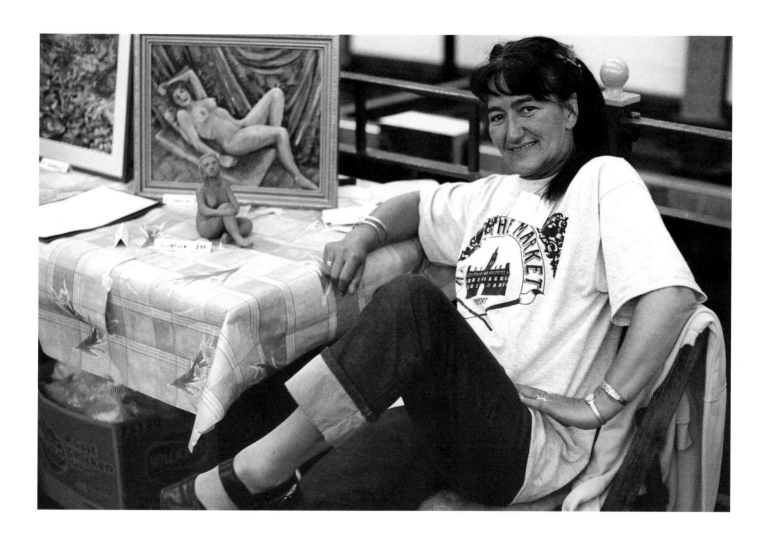

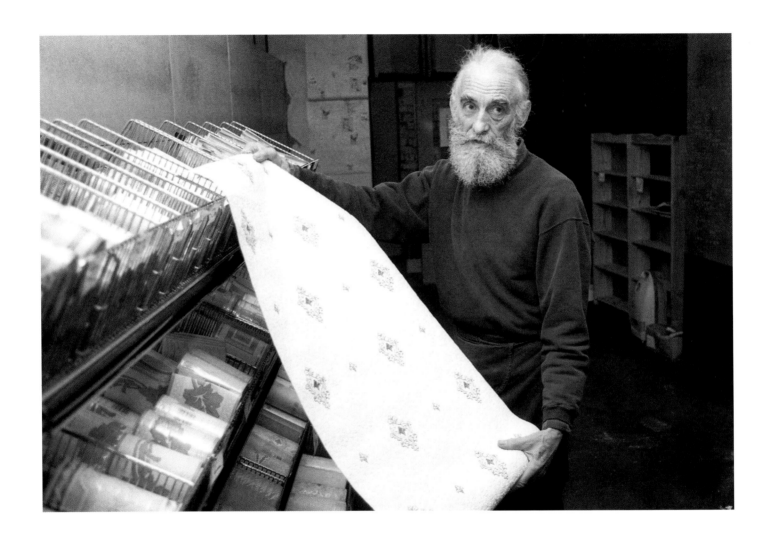

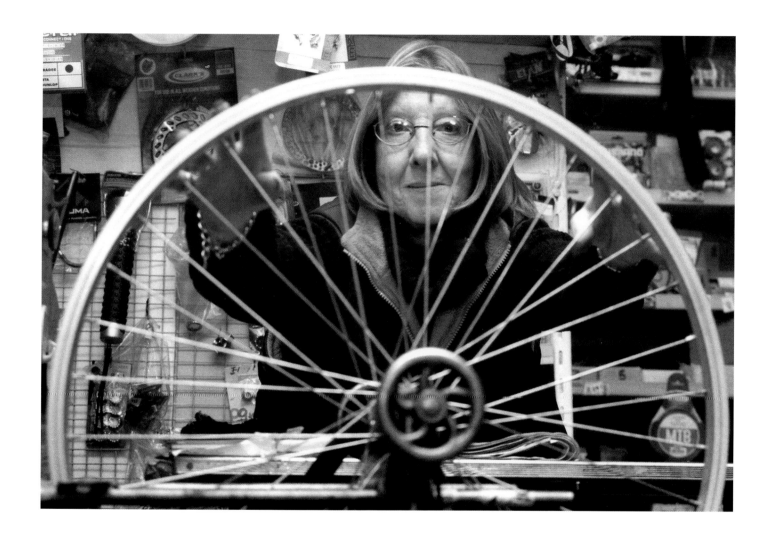

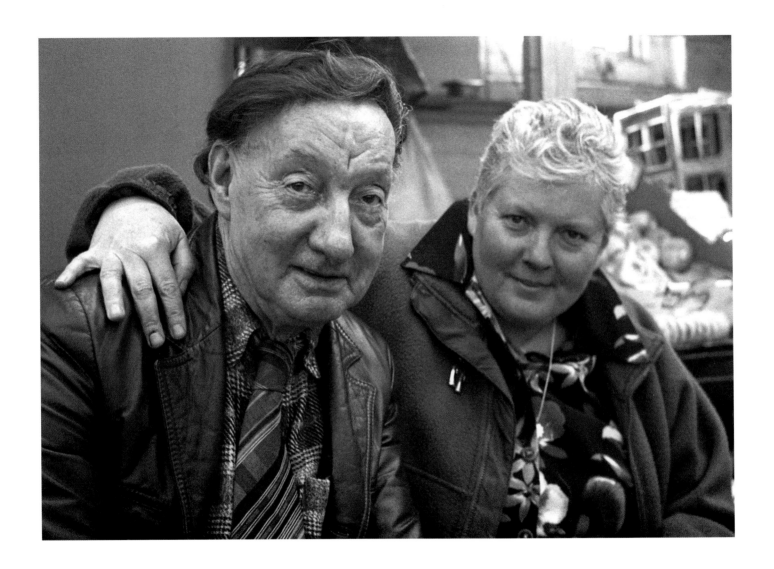

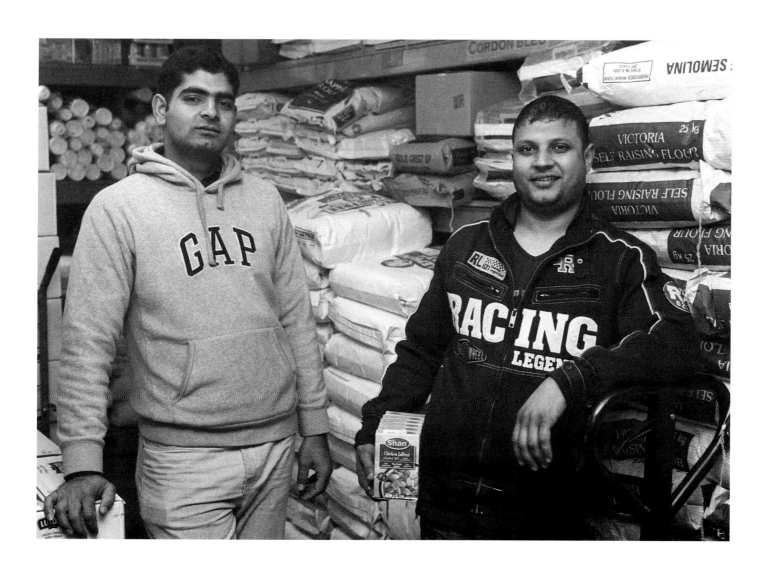

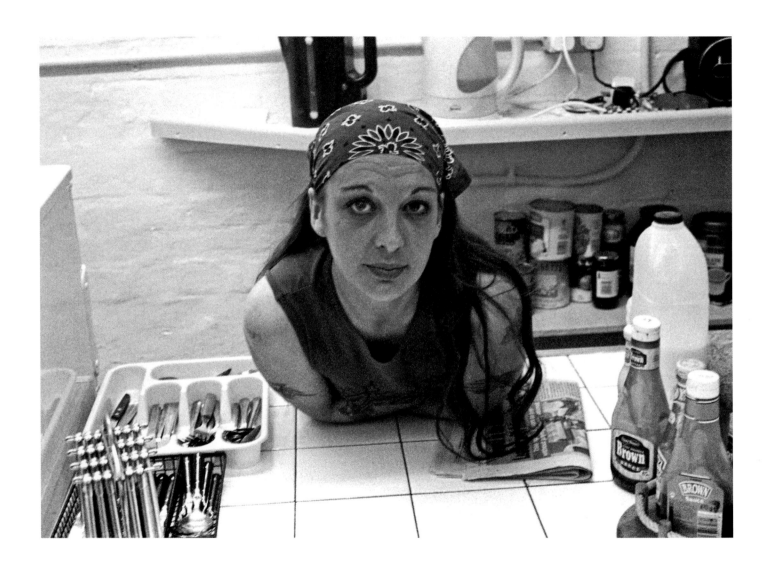

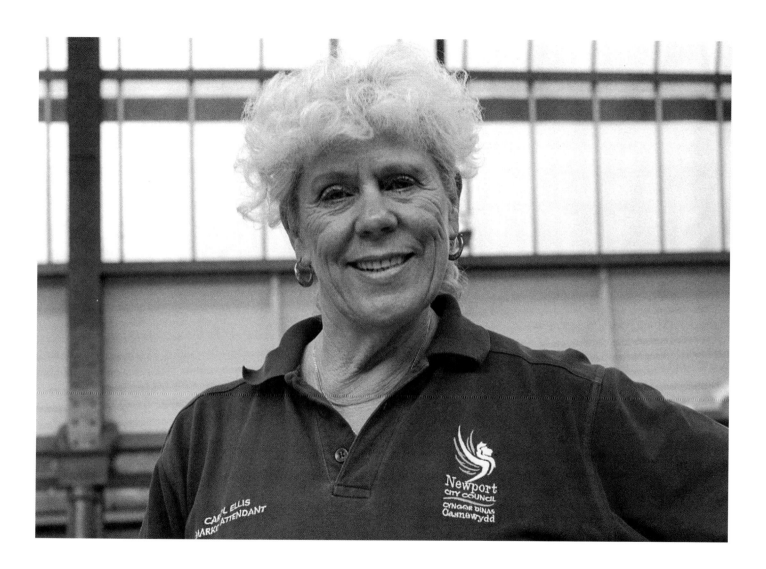

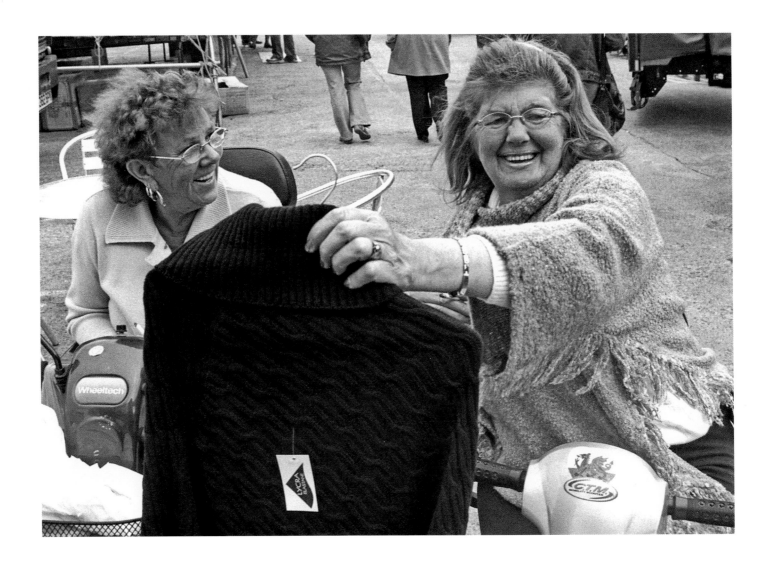

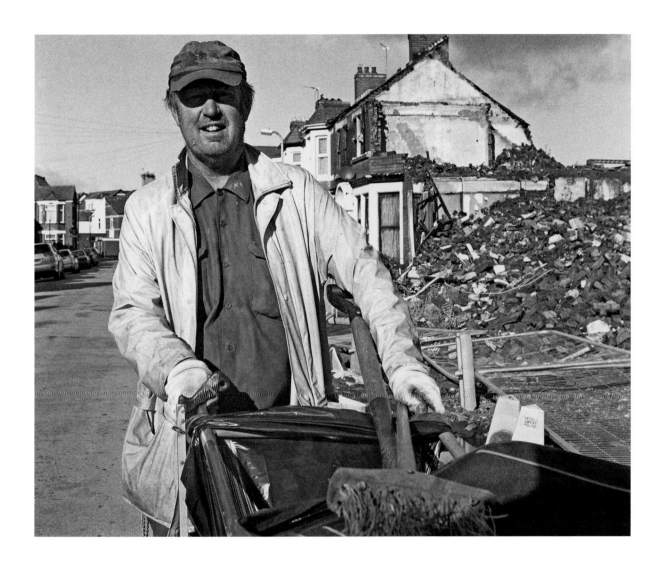

32

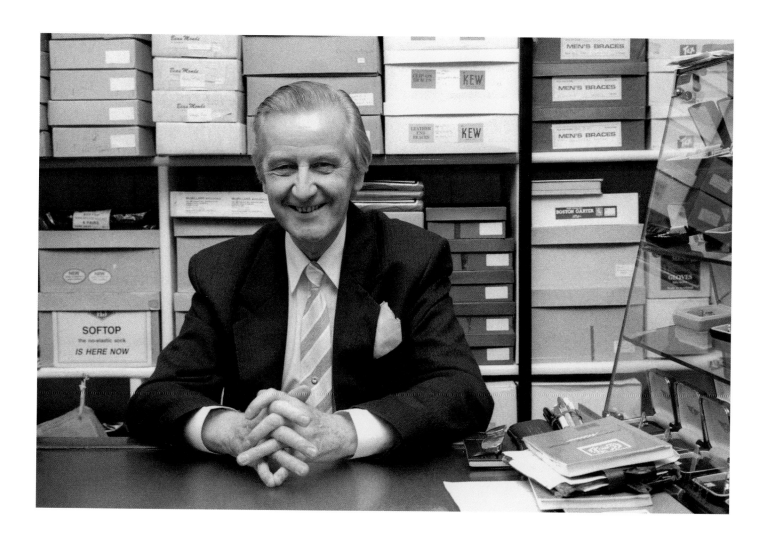

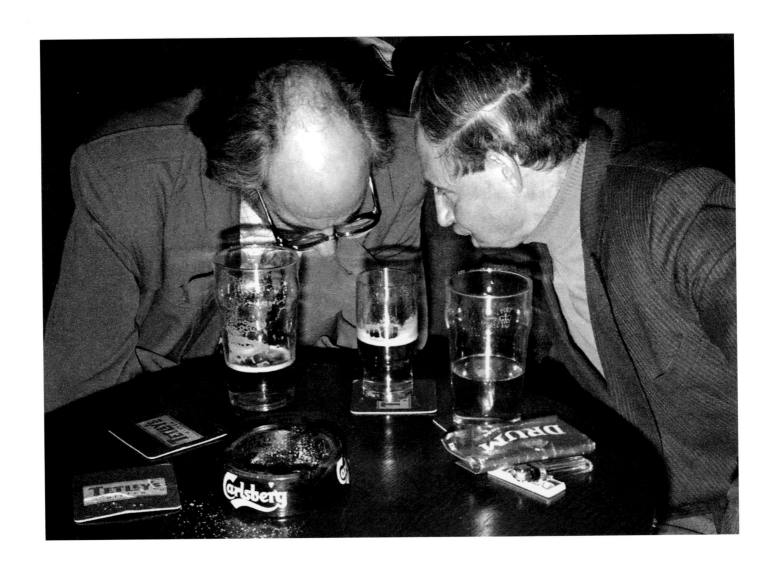

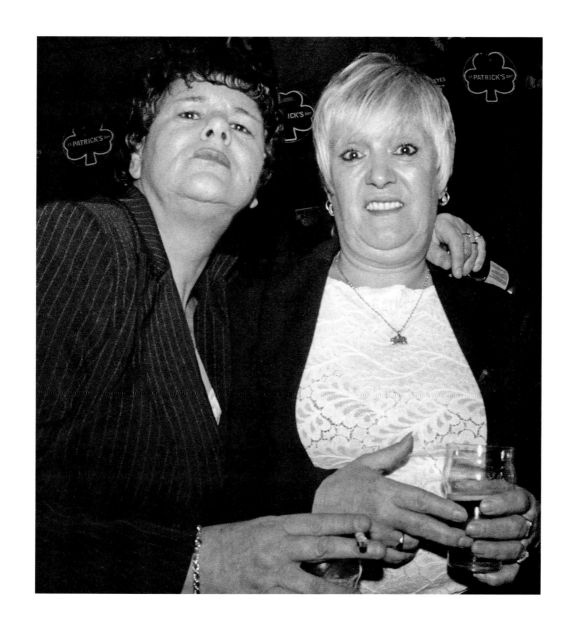

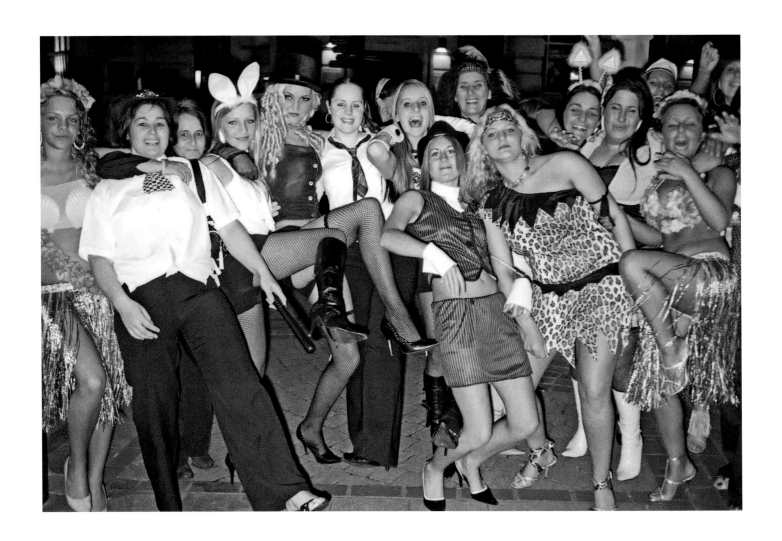

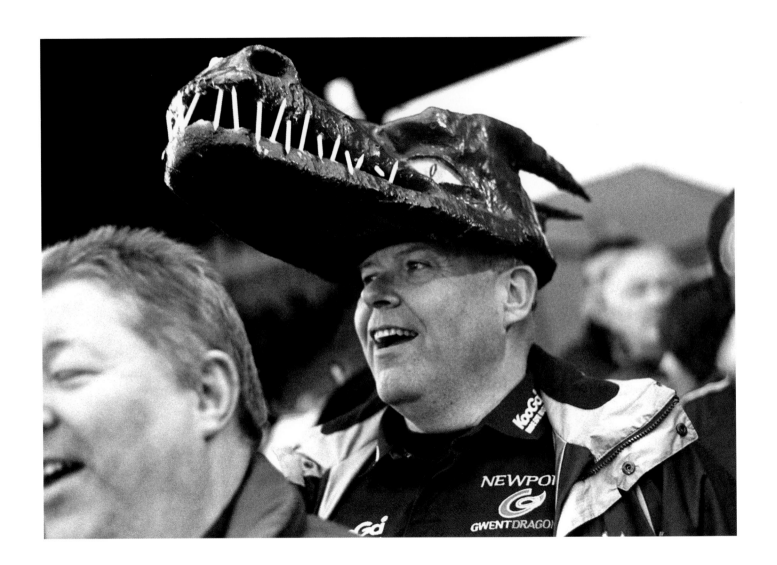

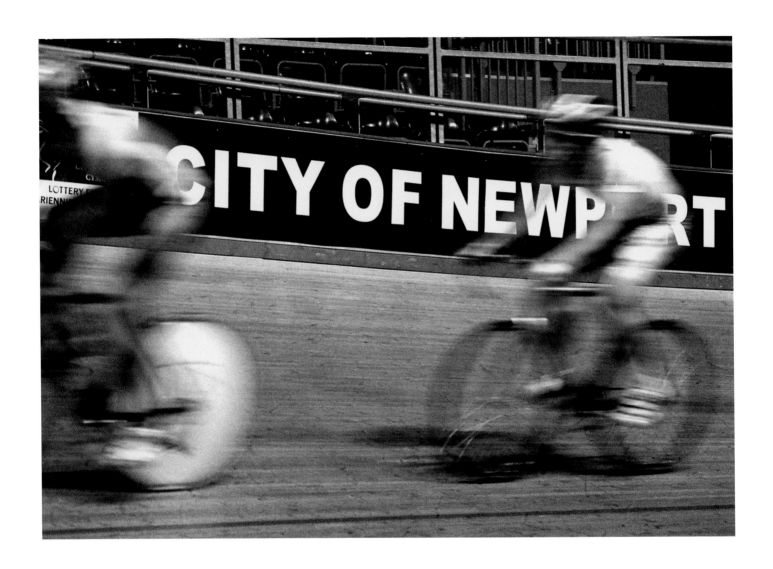

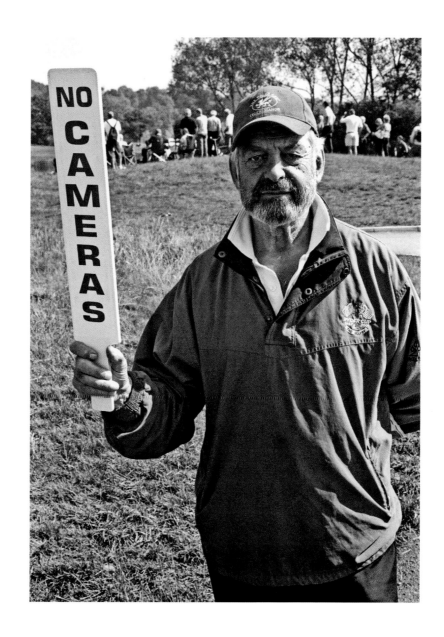

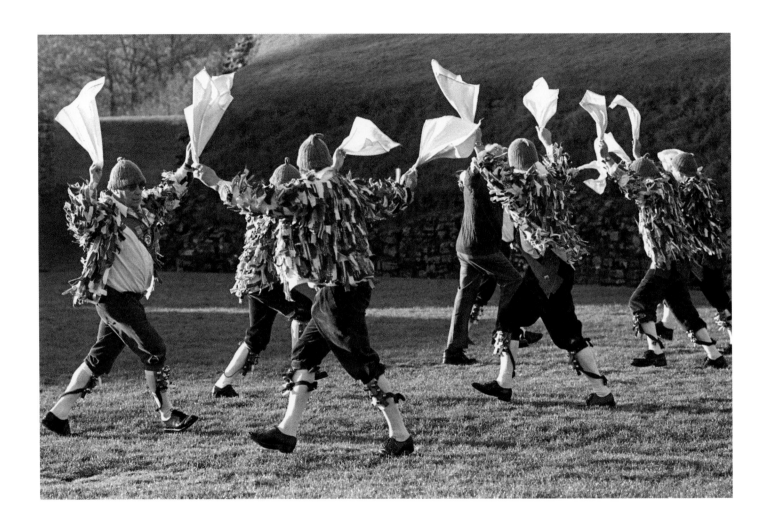

Landmarks & Features

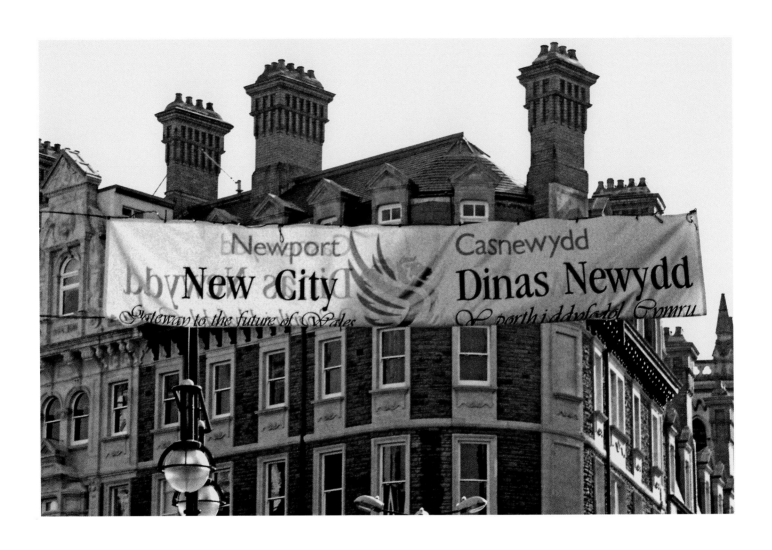

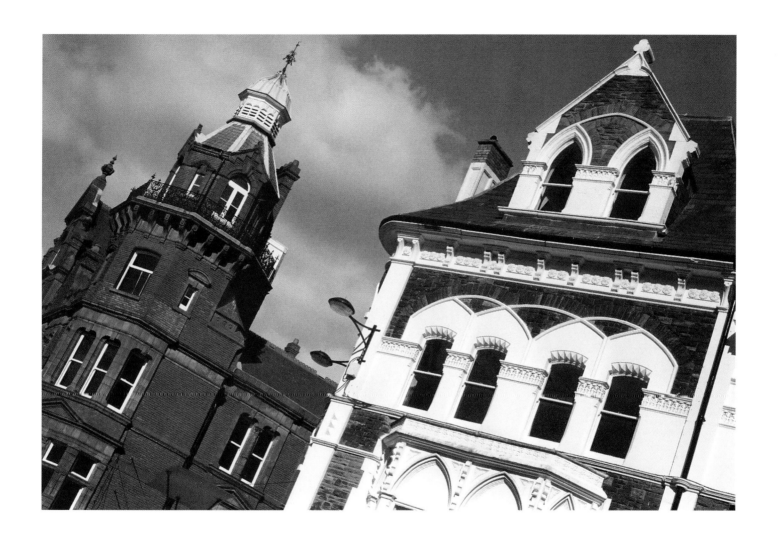

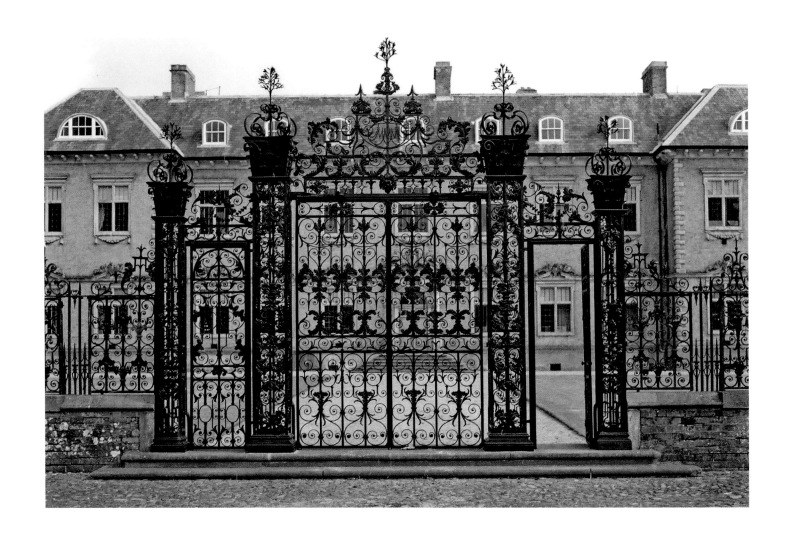

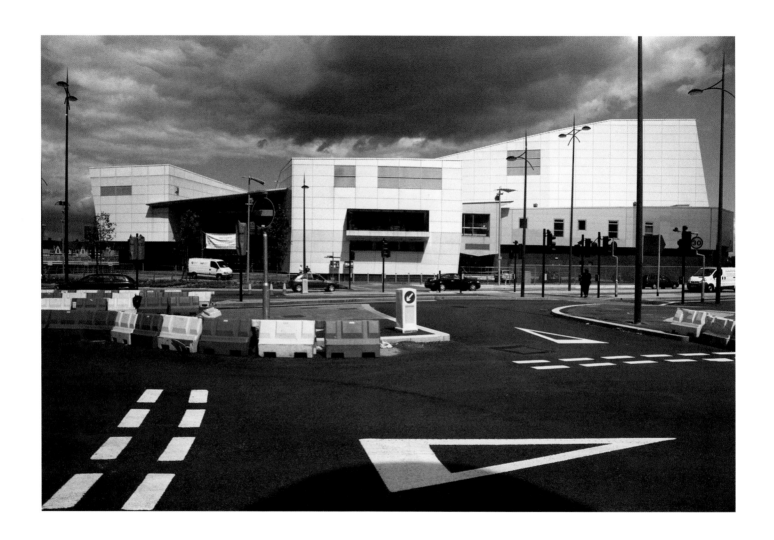

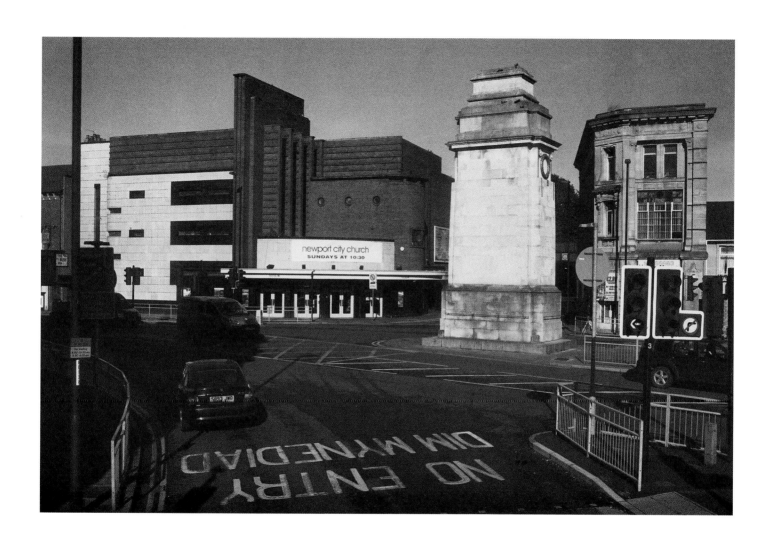

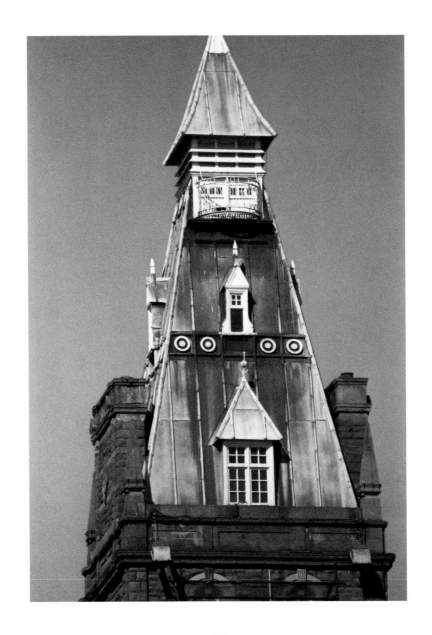

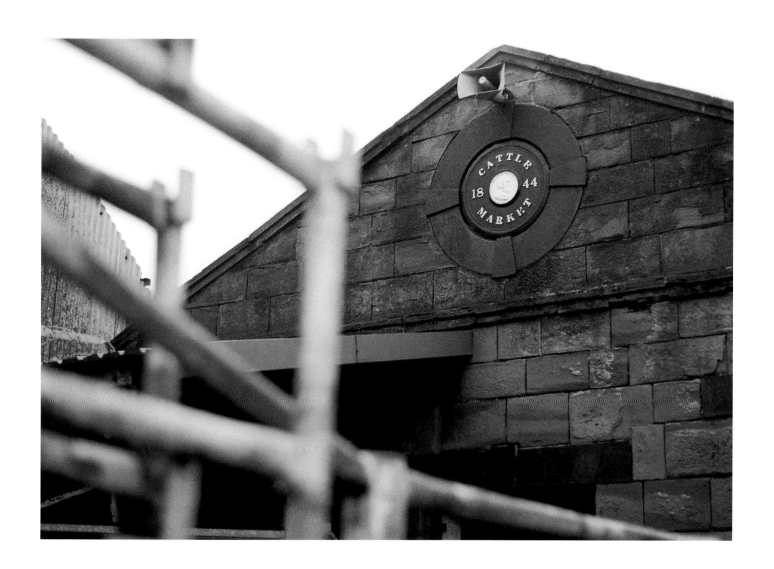

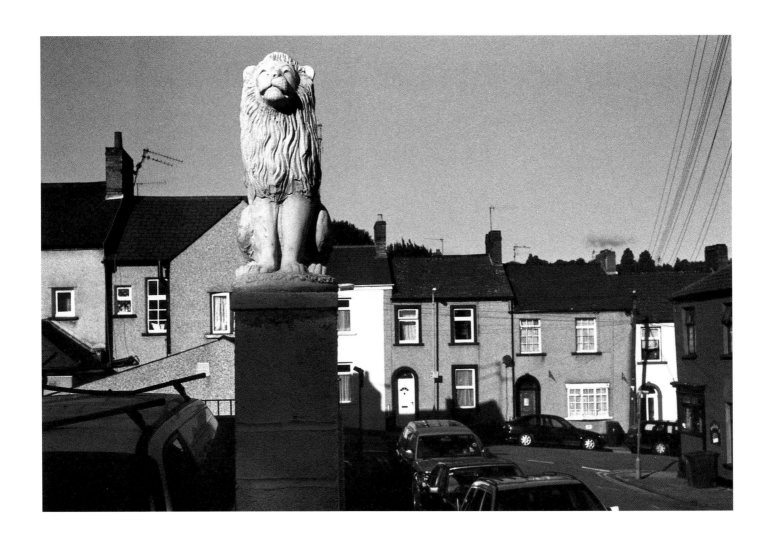

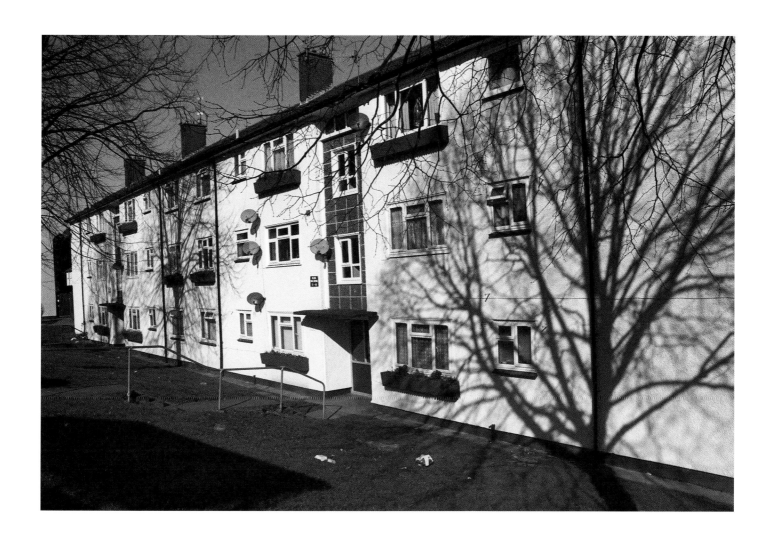

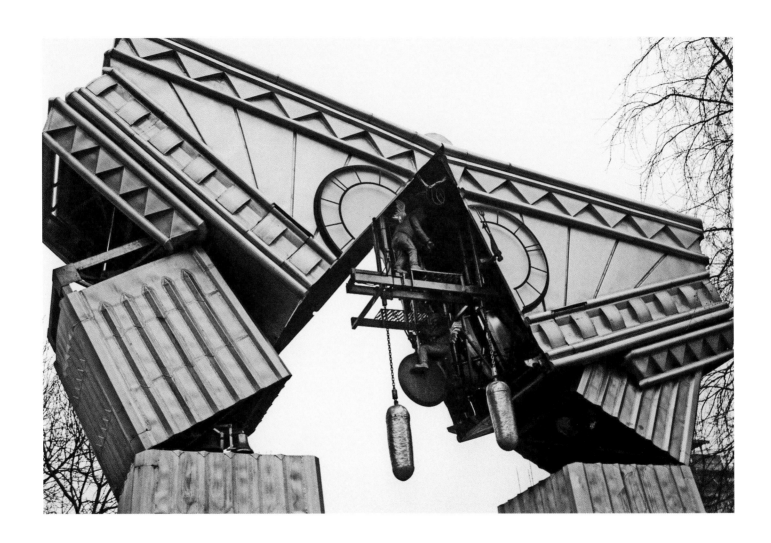

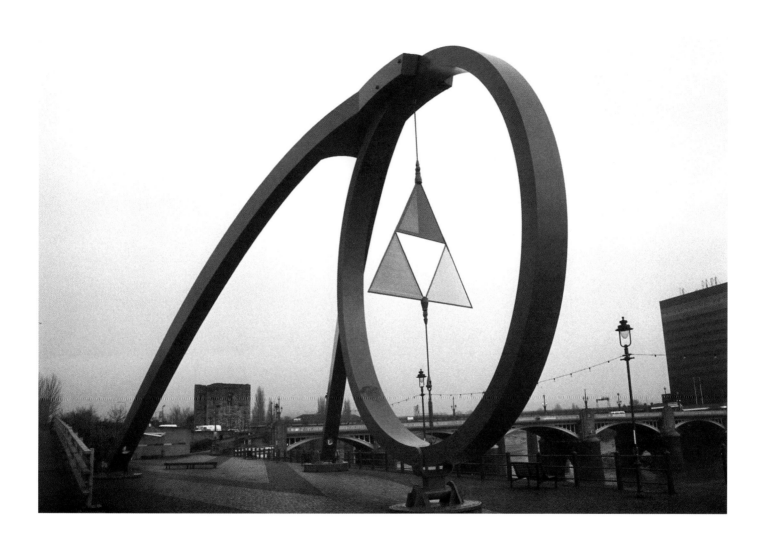

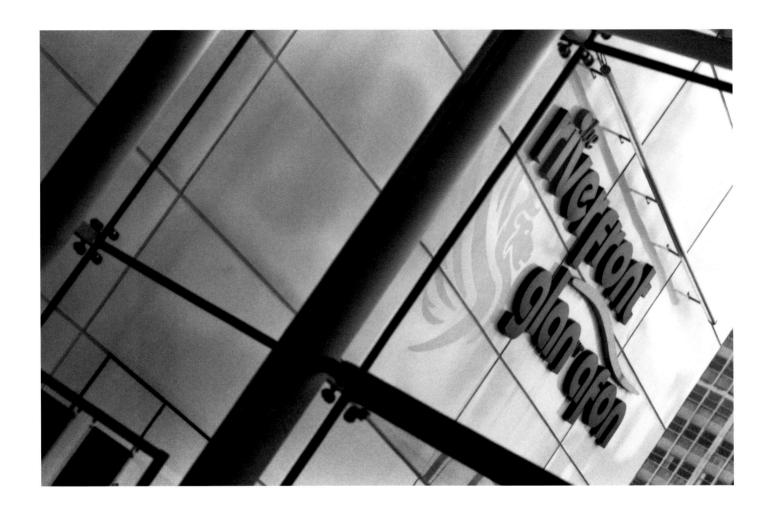

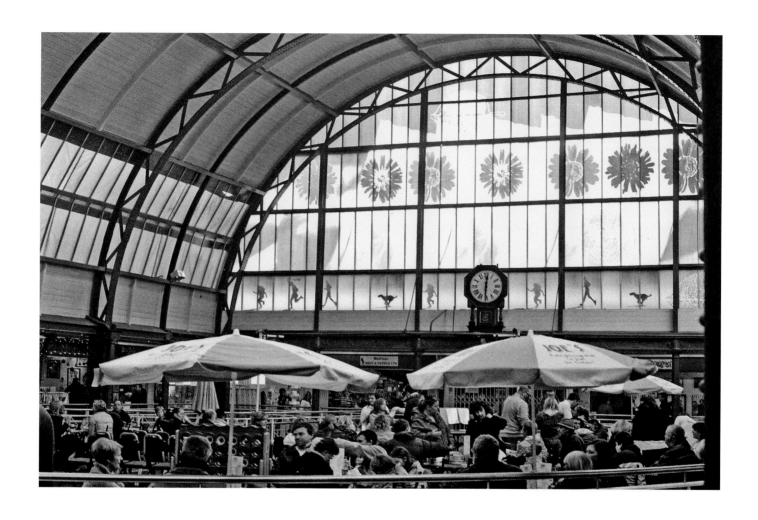

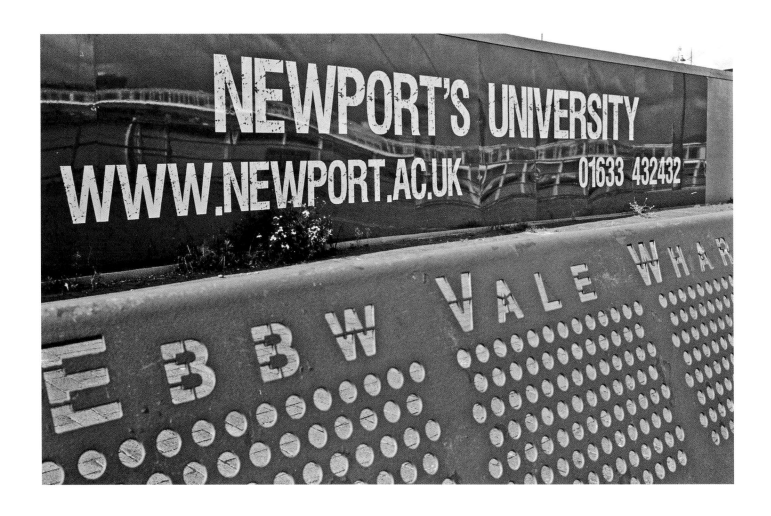

City of Newport

Host City - The 2010 Ryder Cup

Welcomes the World...
for Business, for Leisure

- Under two hours from London, midway between Cardiff and Bristol
- 1.5 million people within a 45 minute drive time
- Surrounded by breathtaking scenery
- Diverse artistic, leisure, sporting and cultural scene
- A rapidly transforming city with £billions of private sector investment

www.newport.gov.uk
inward.investment@newport...

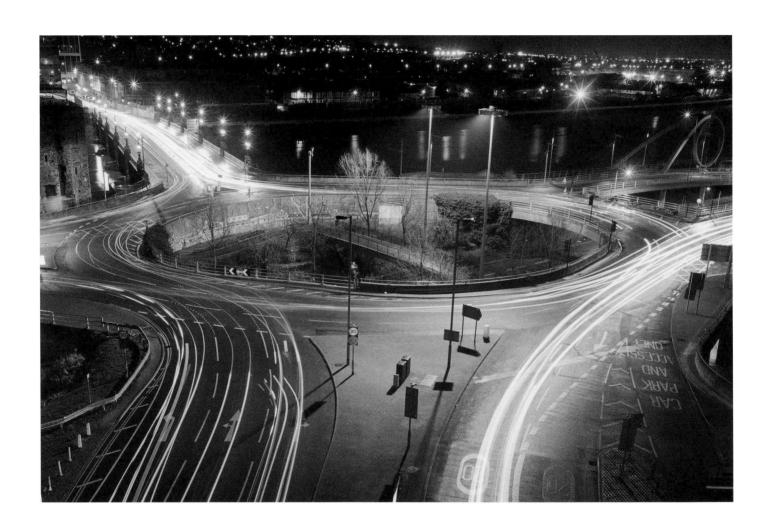

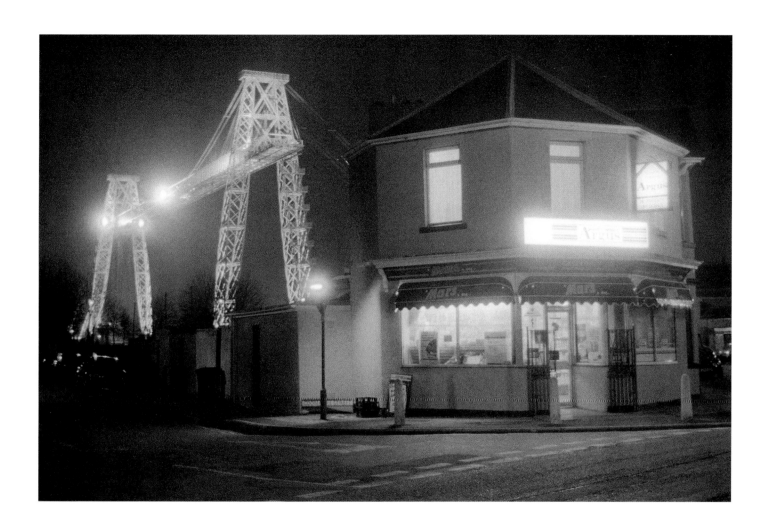

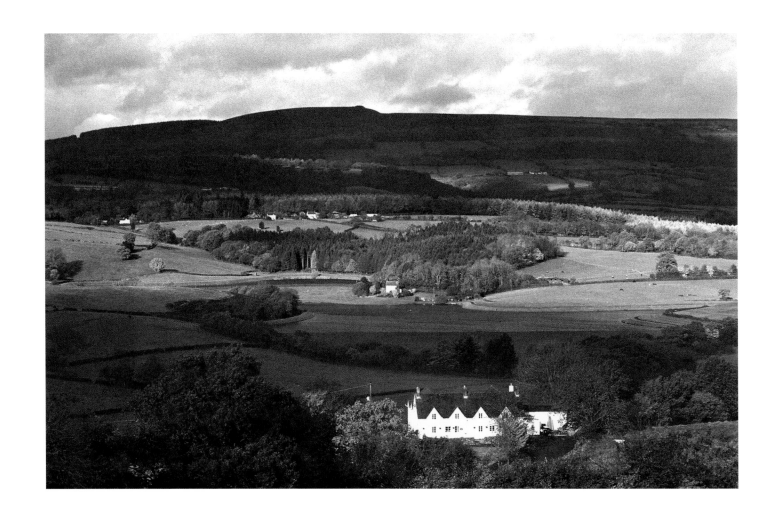

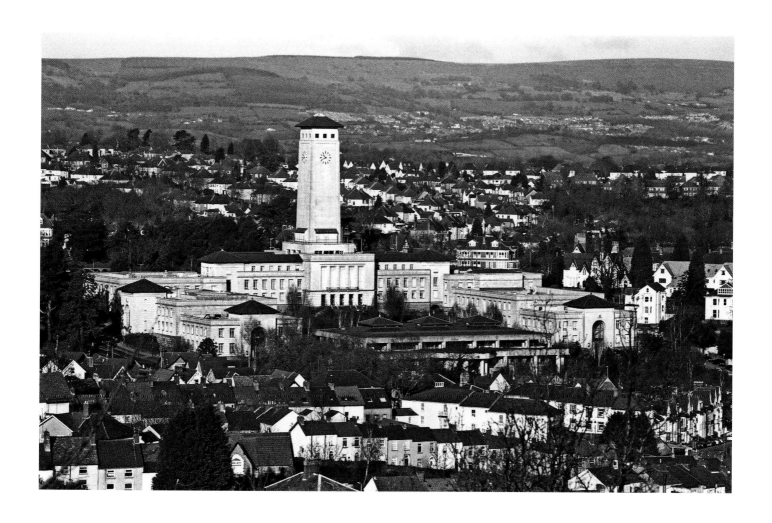

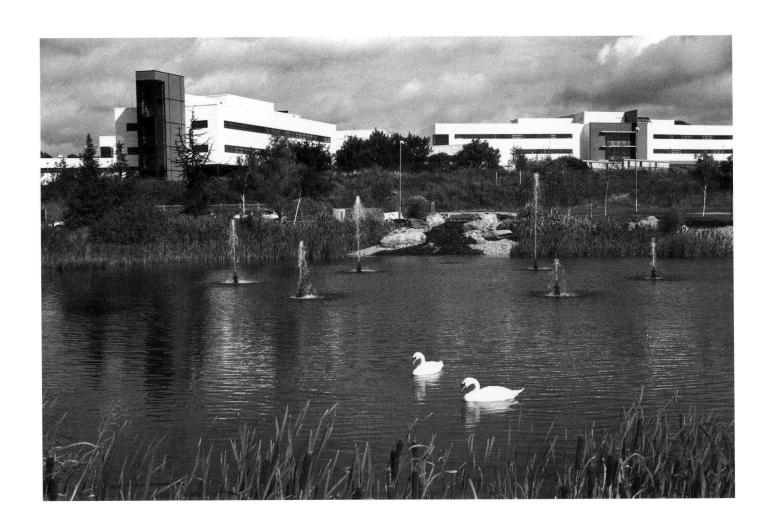

City People (2)

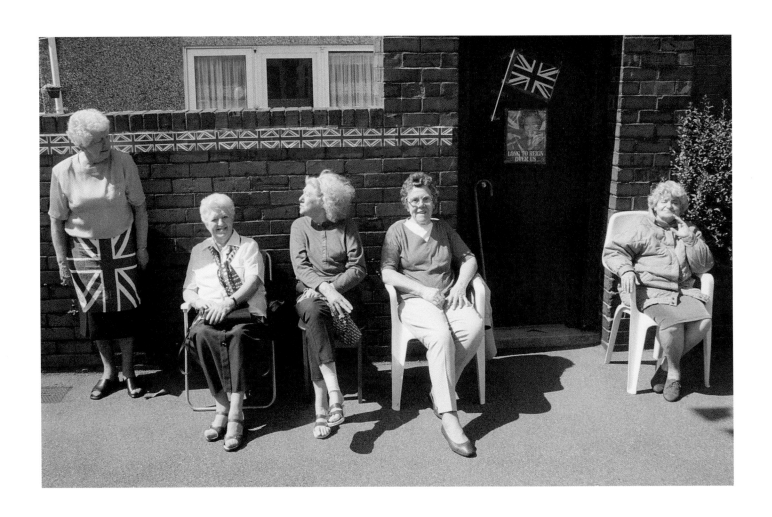

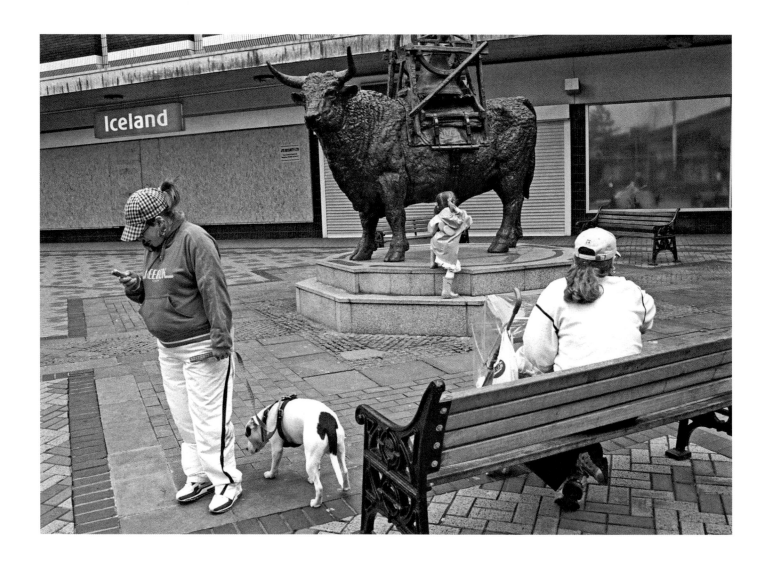

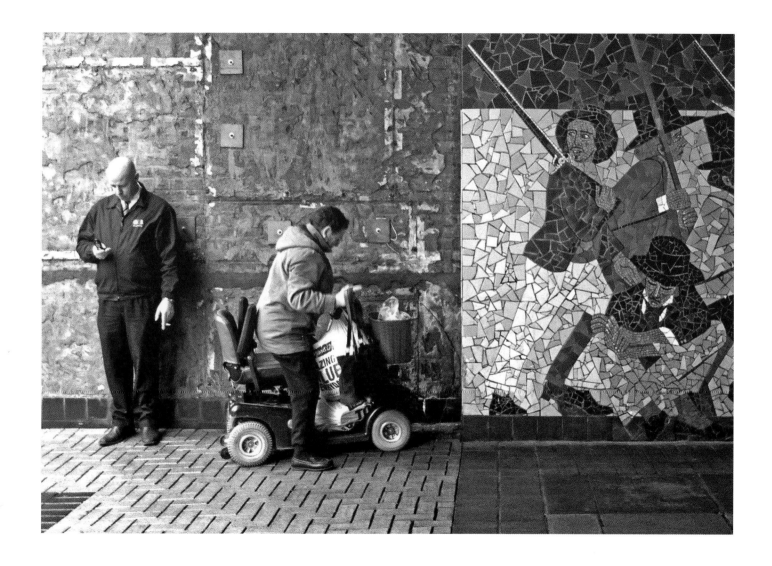

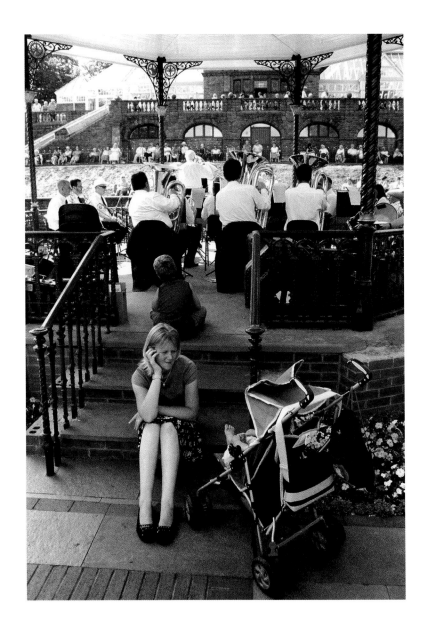

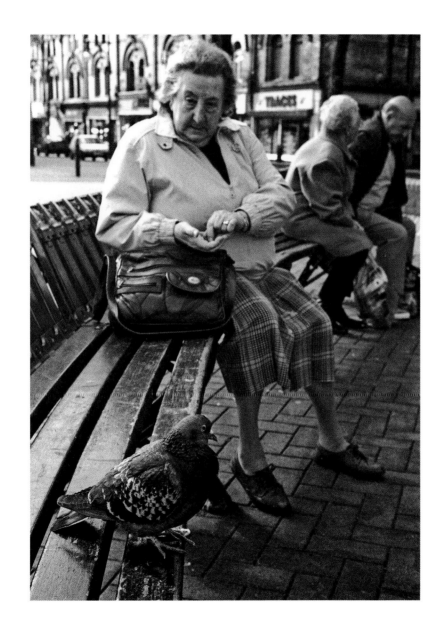

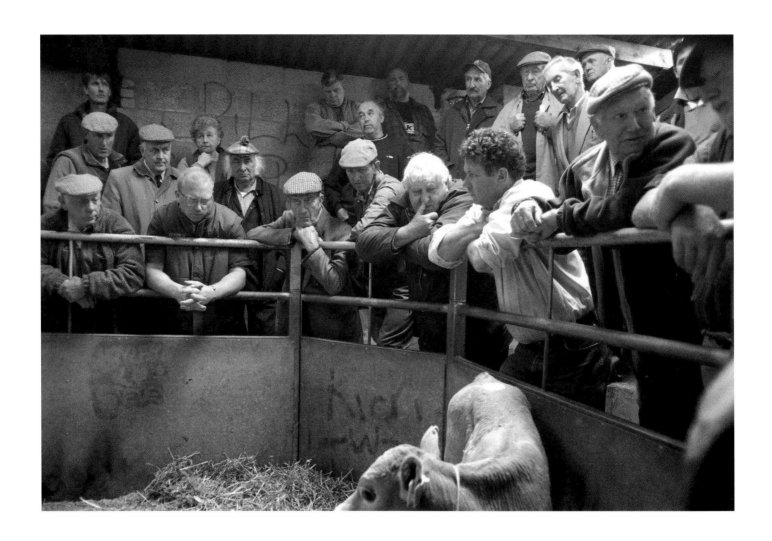

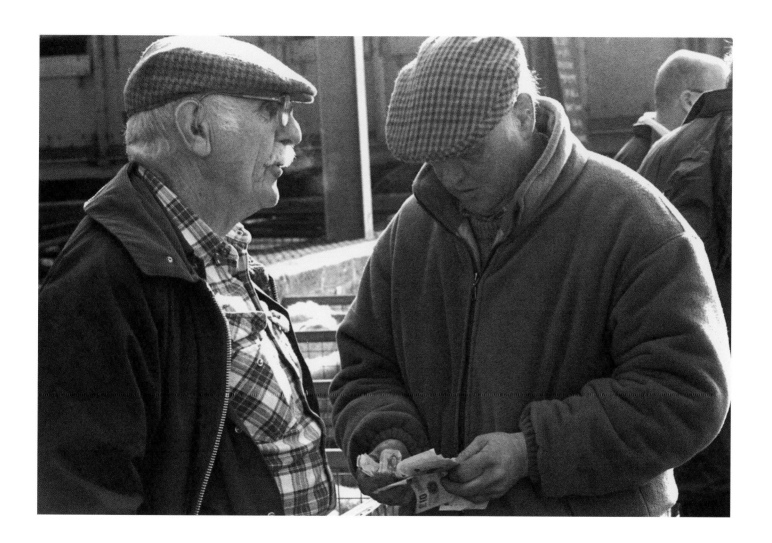

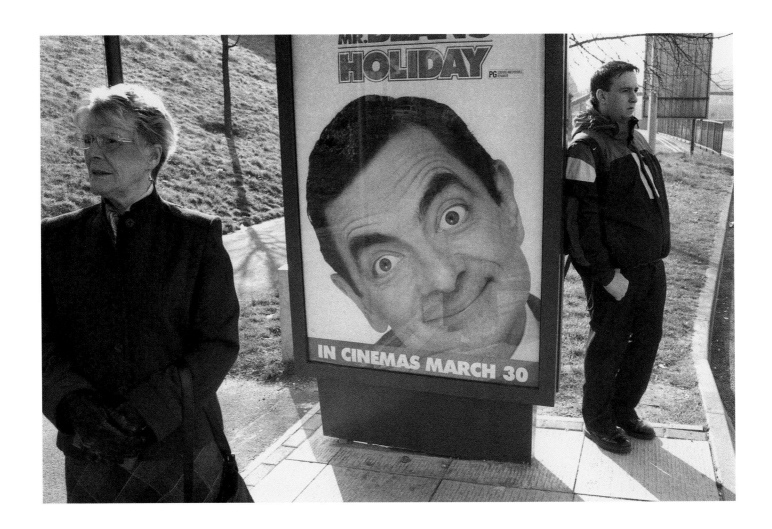

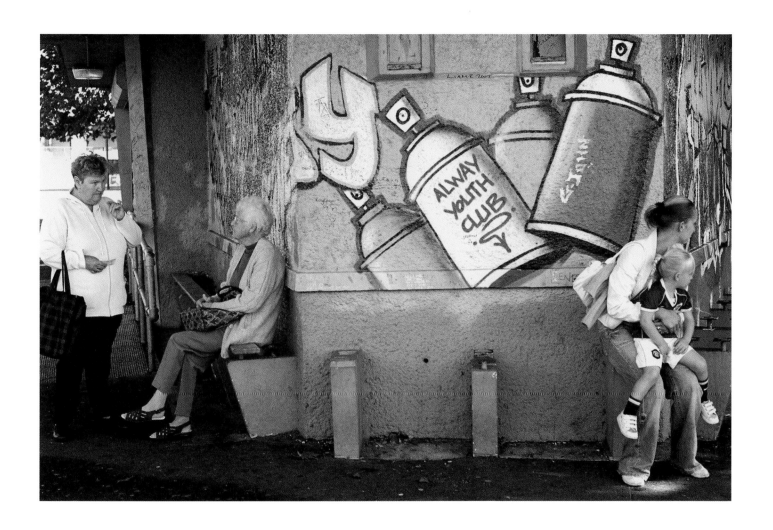

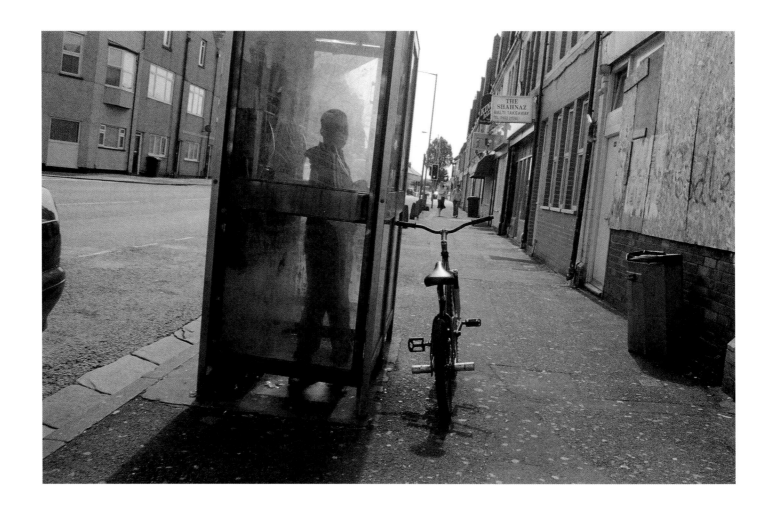

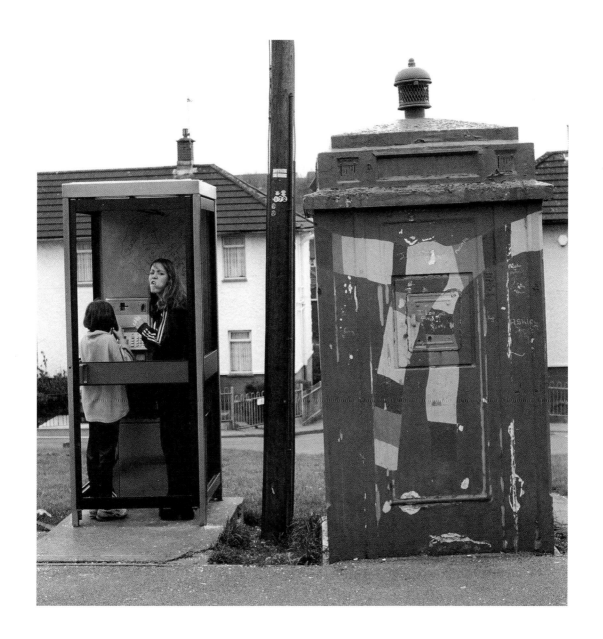

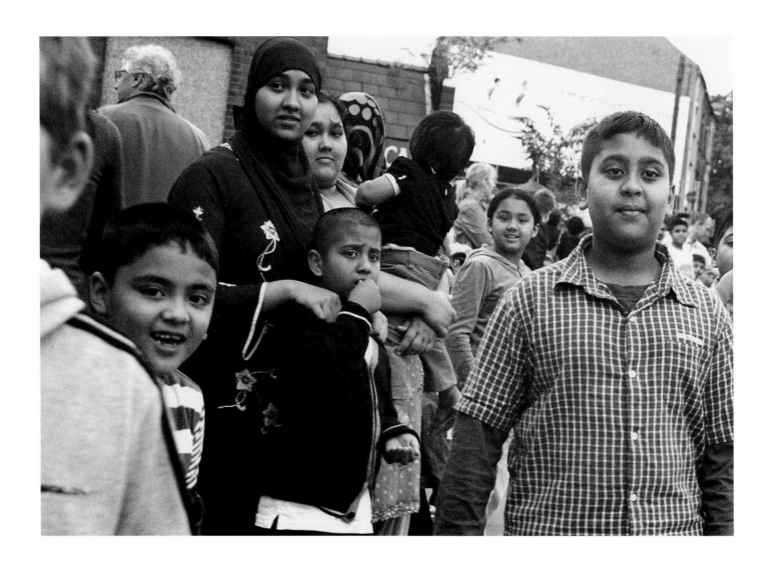

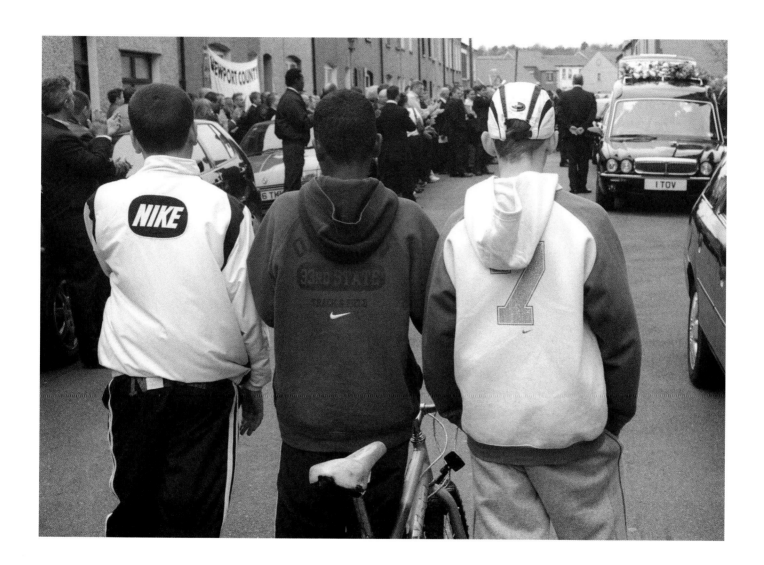

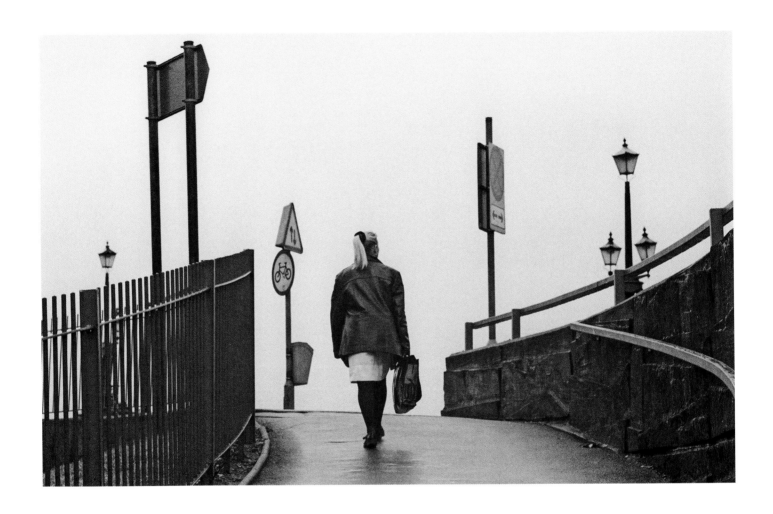

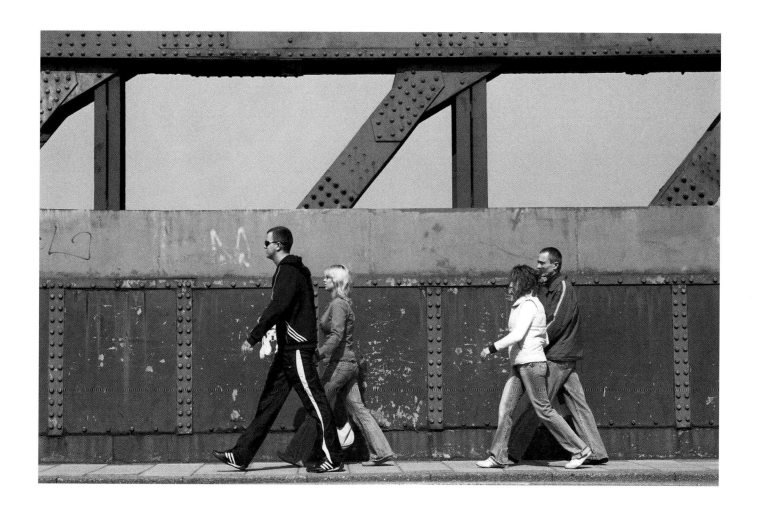

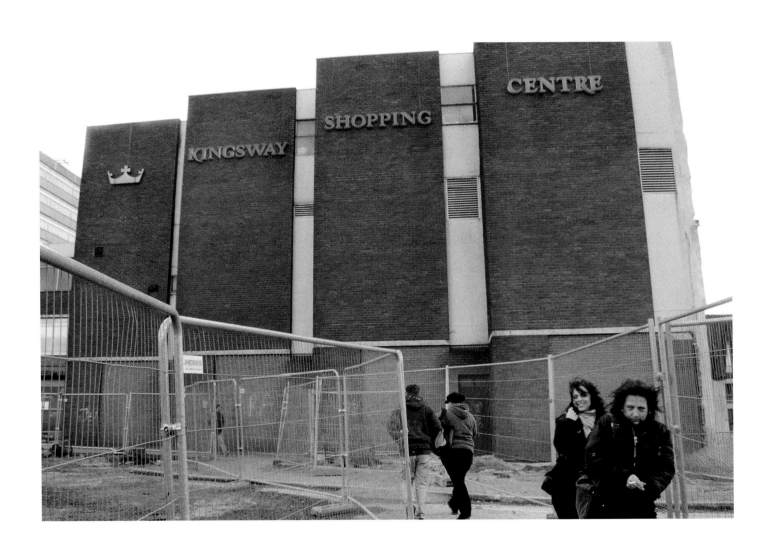

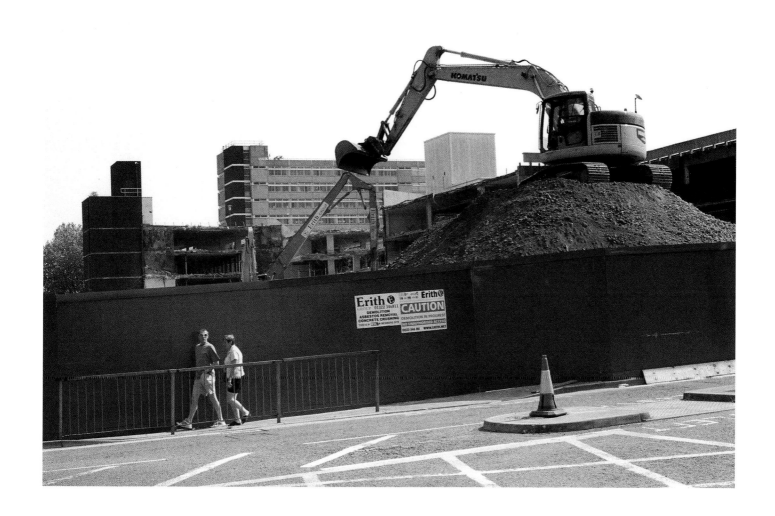

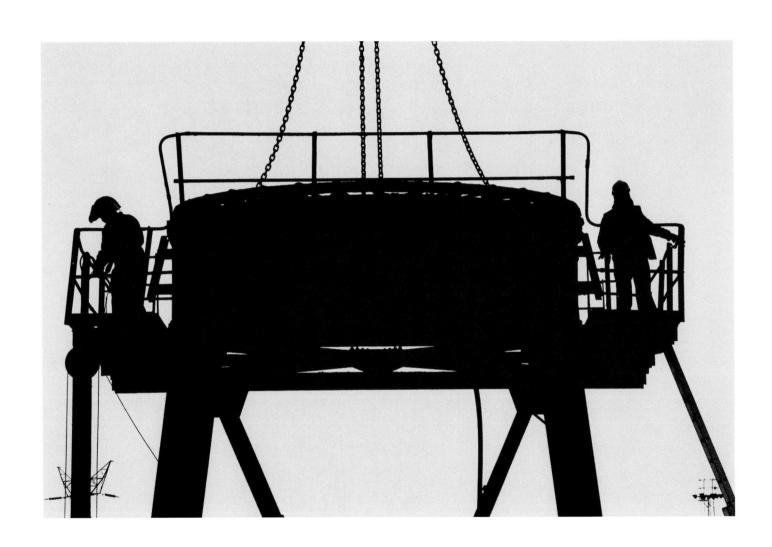

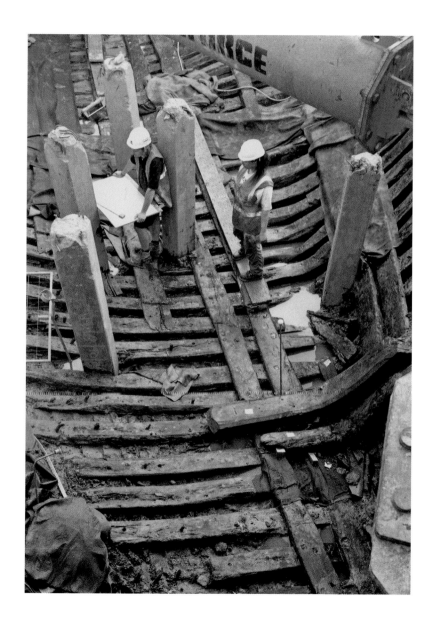

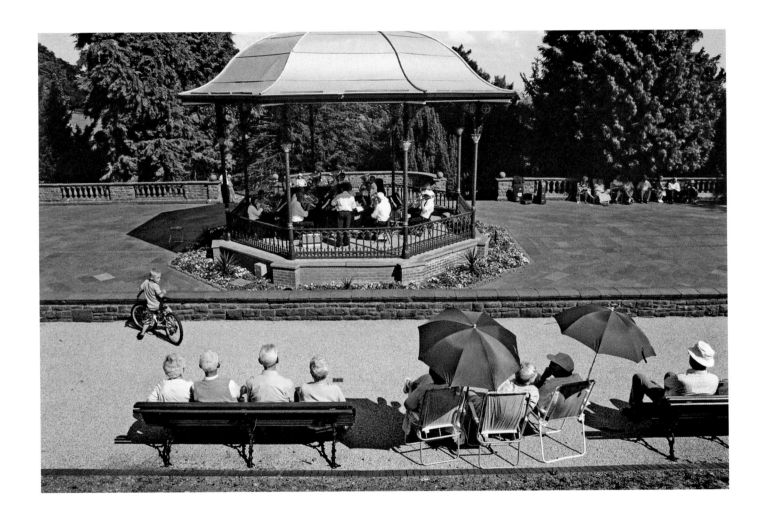

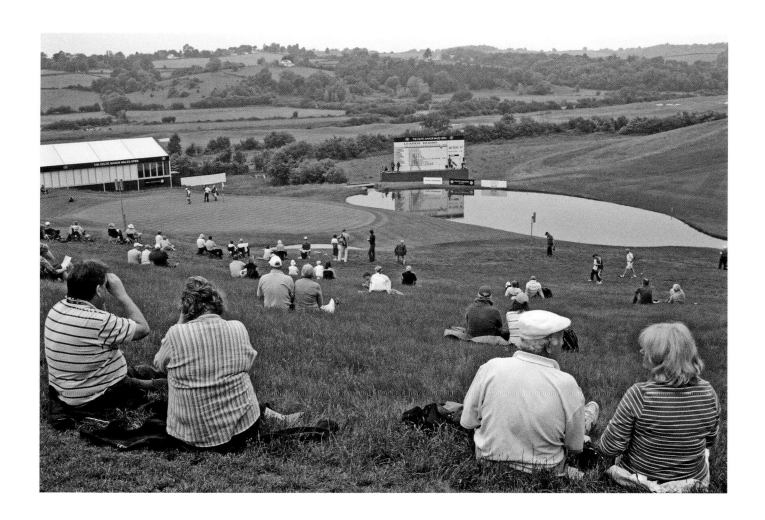

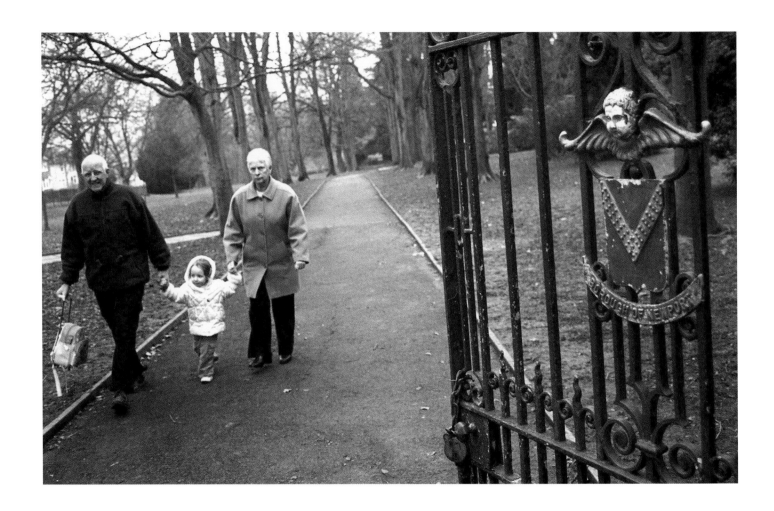

Industrial, Maritime & Riverscape

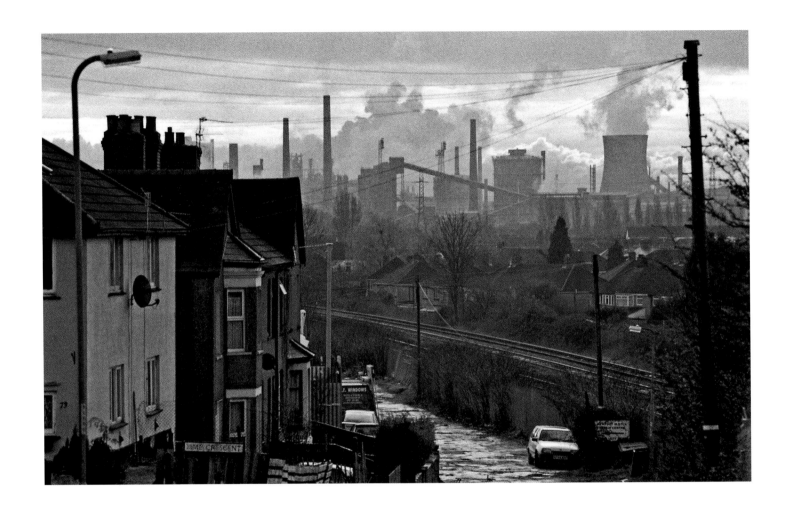

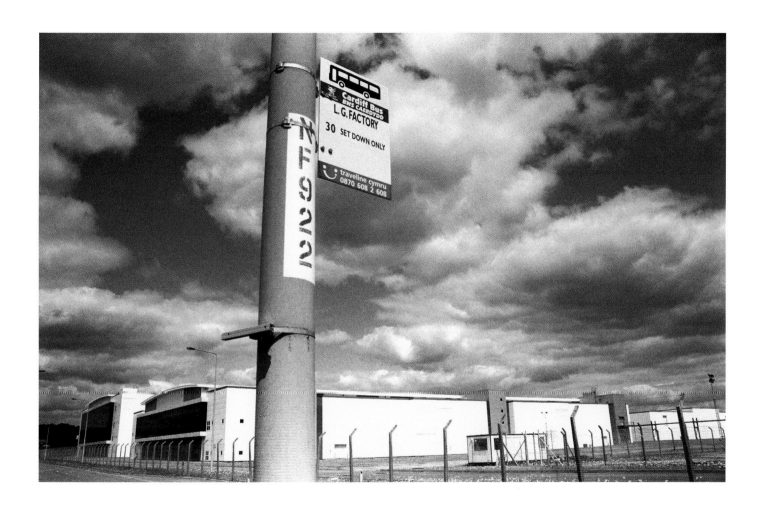

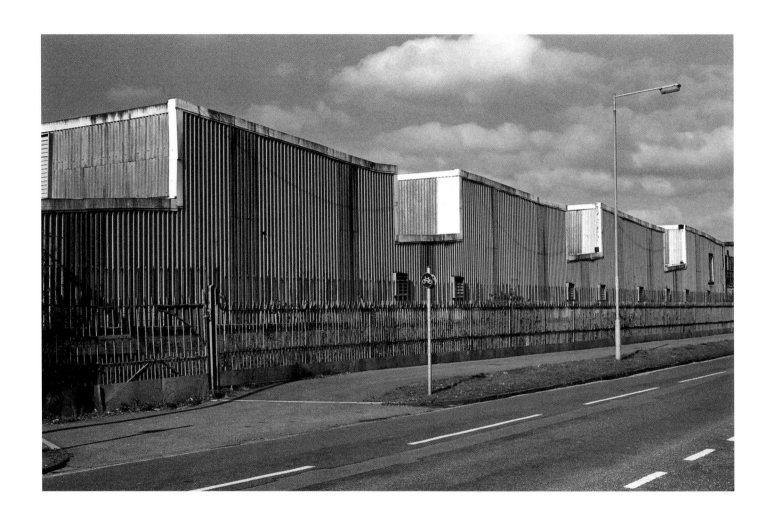

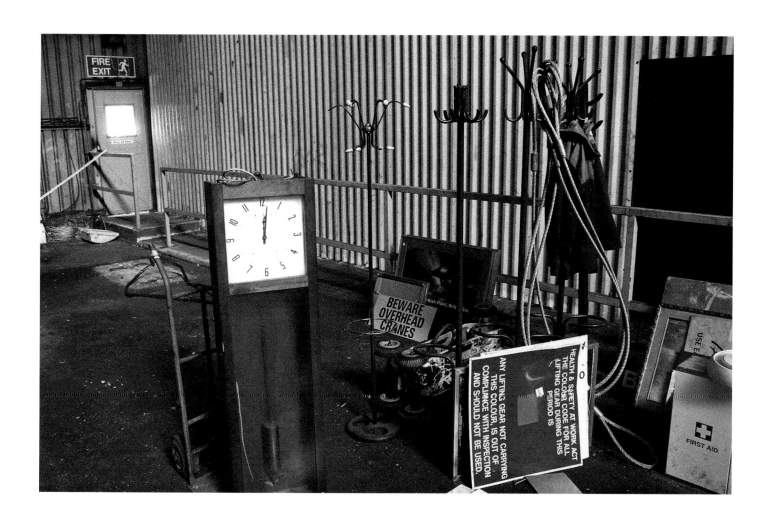

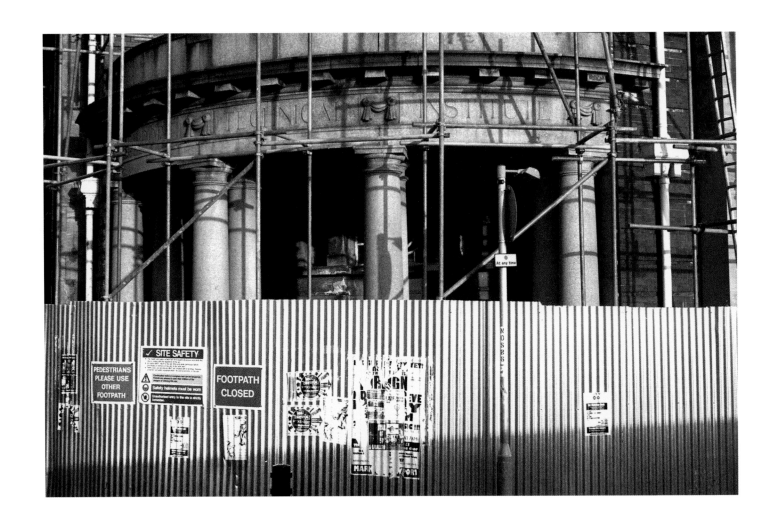

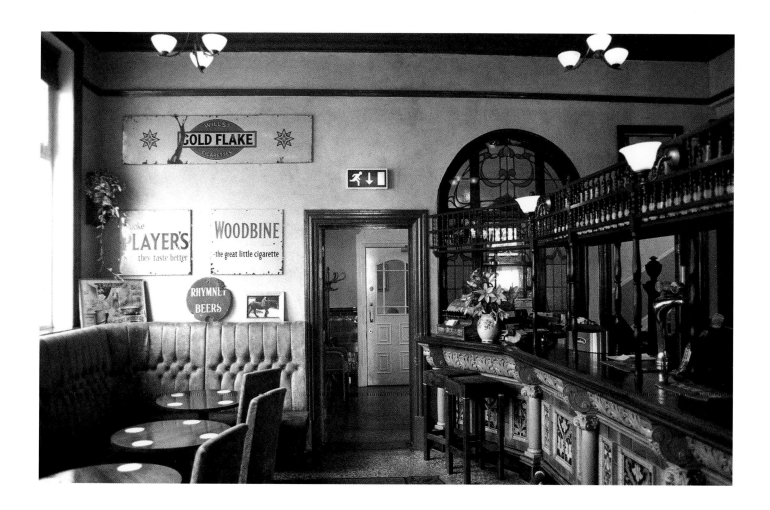

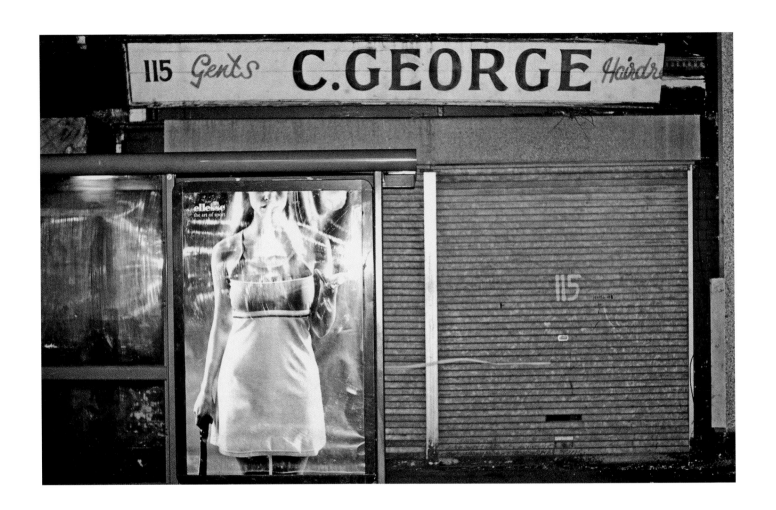

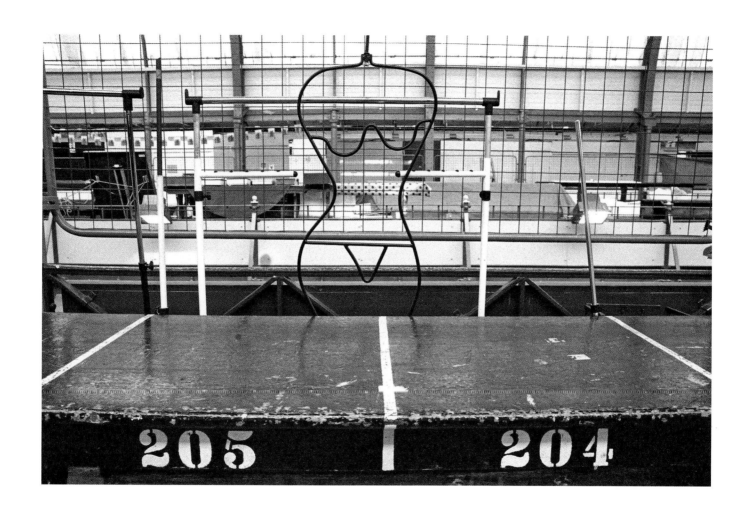

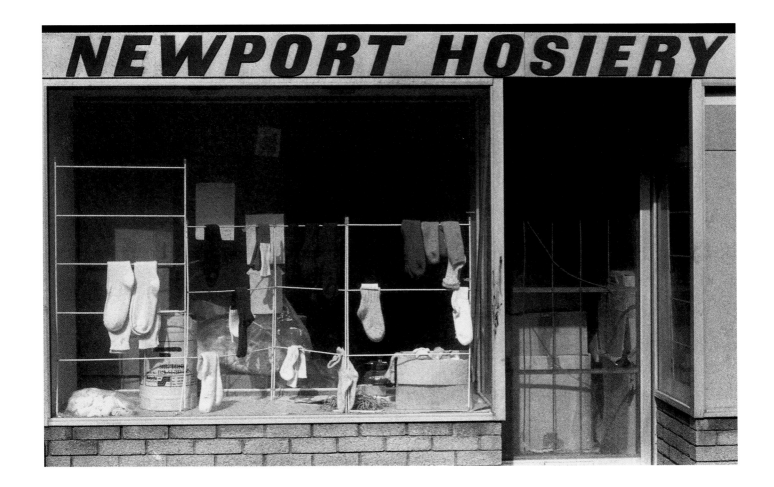

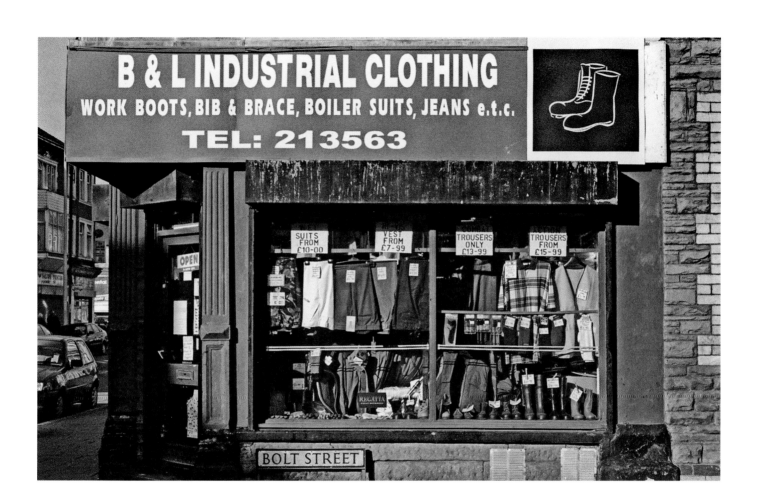

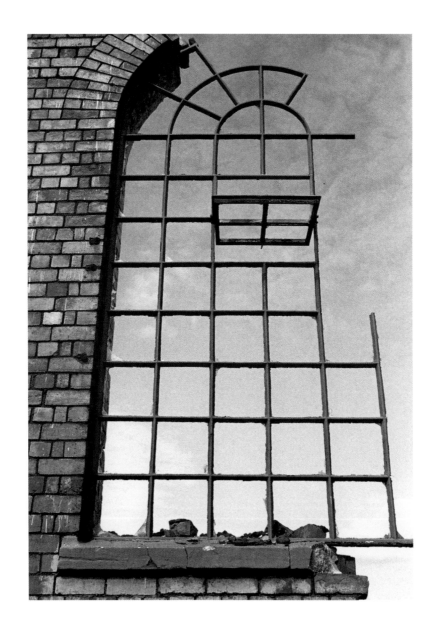

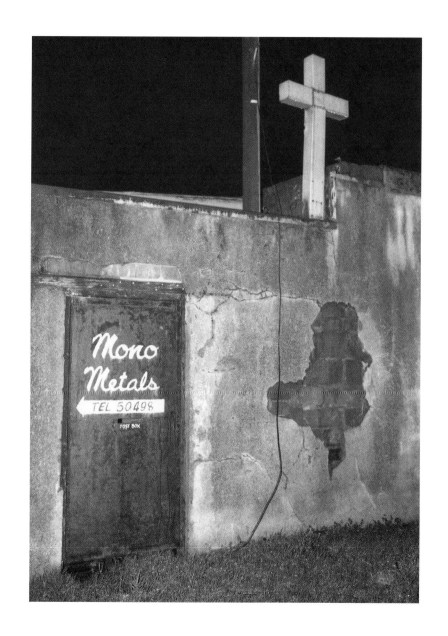

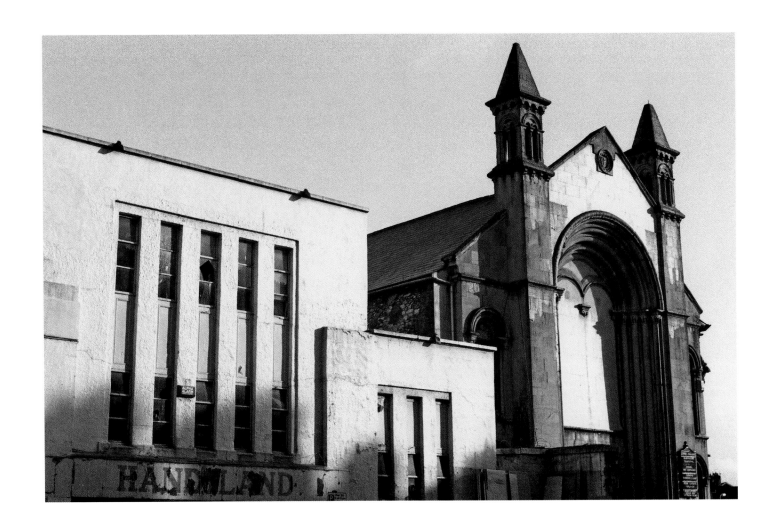

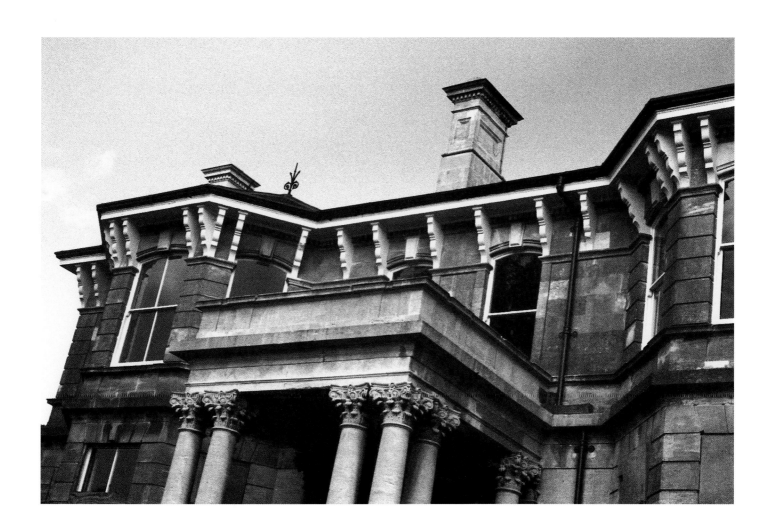

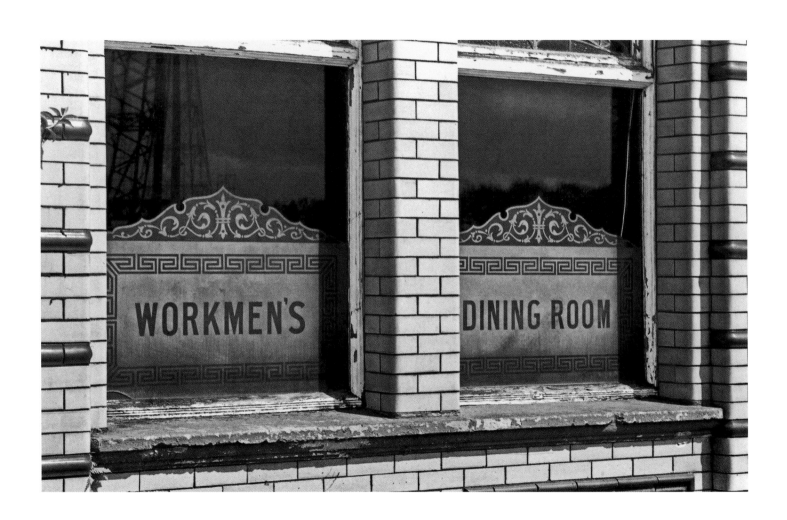

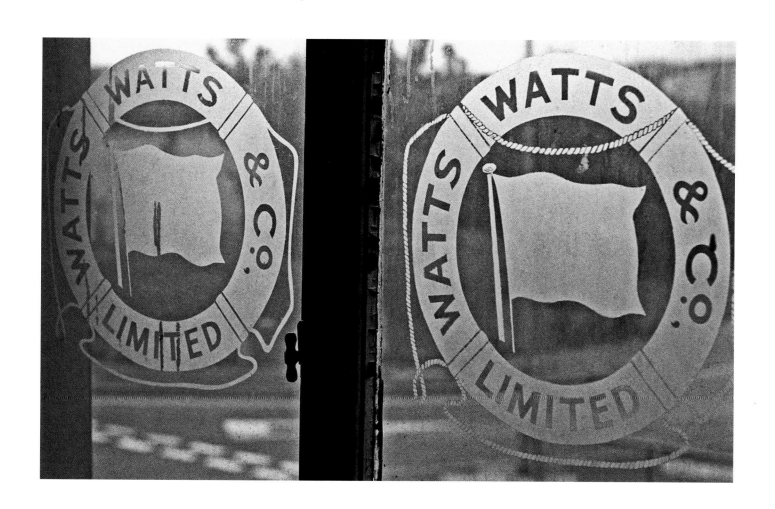

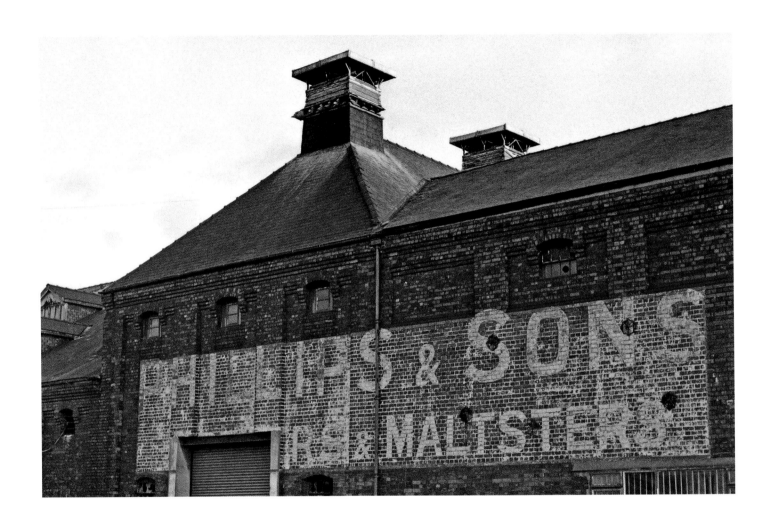

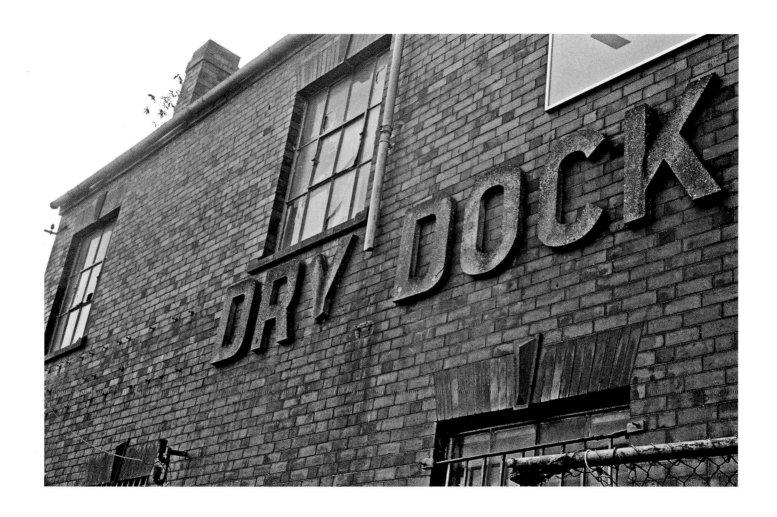

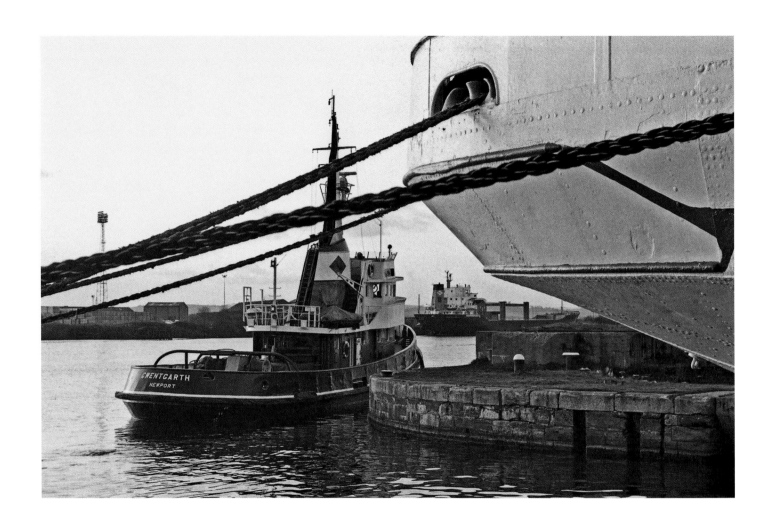

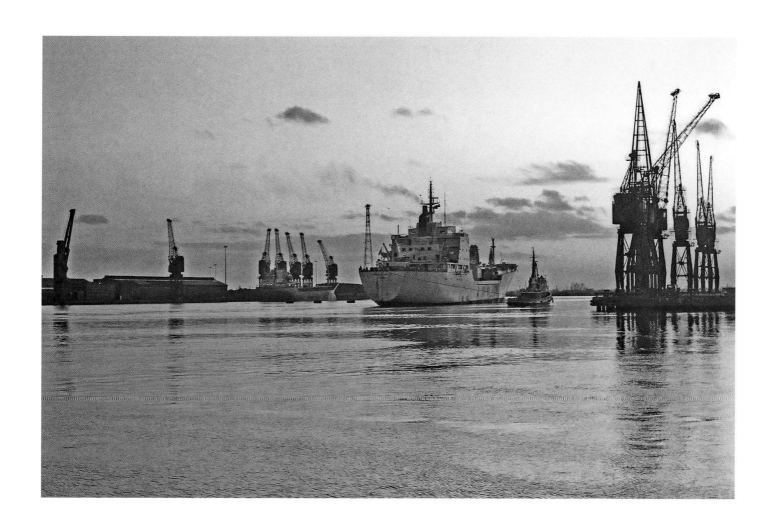

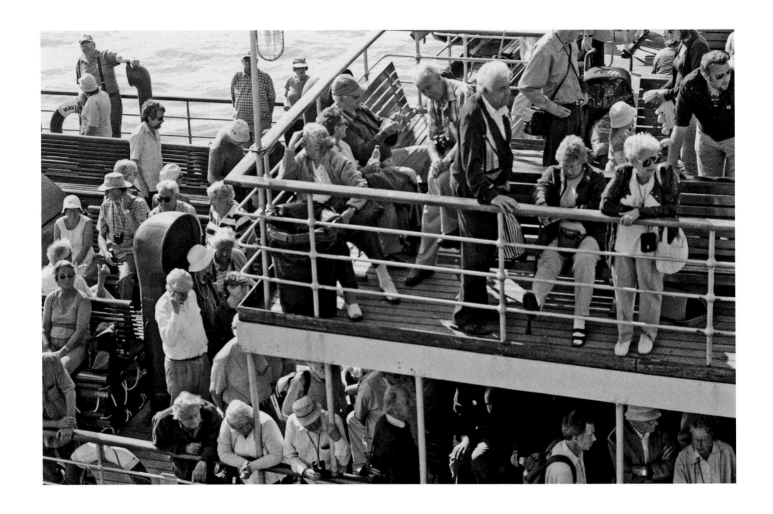

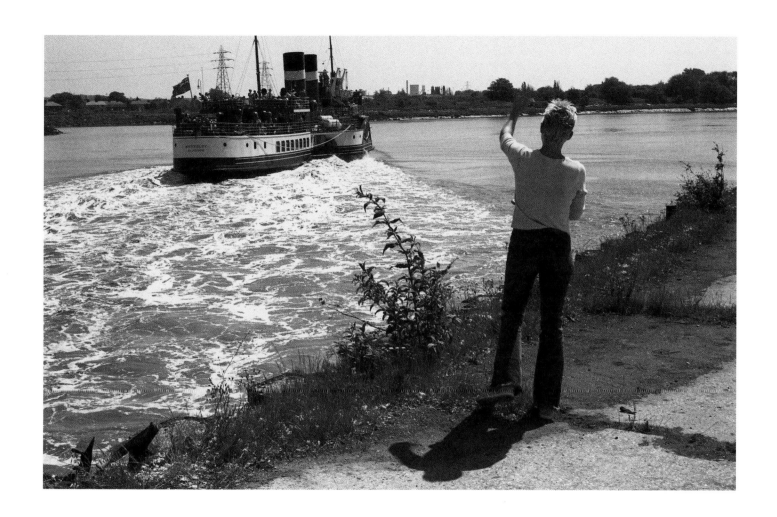

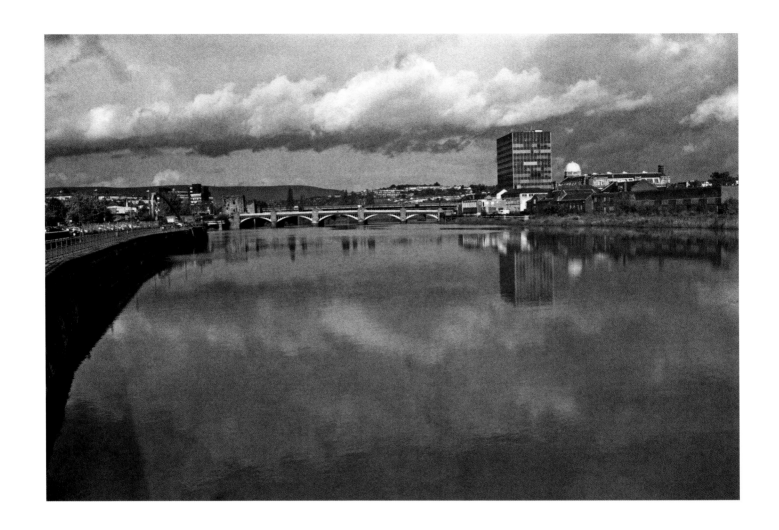

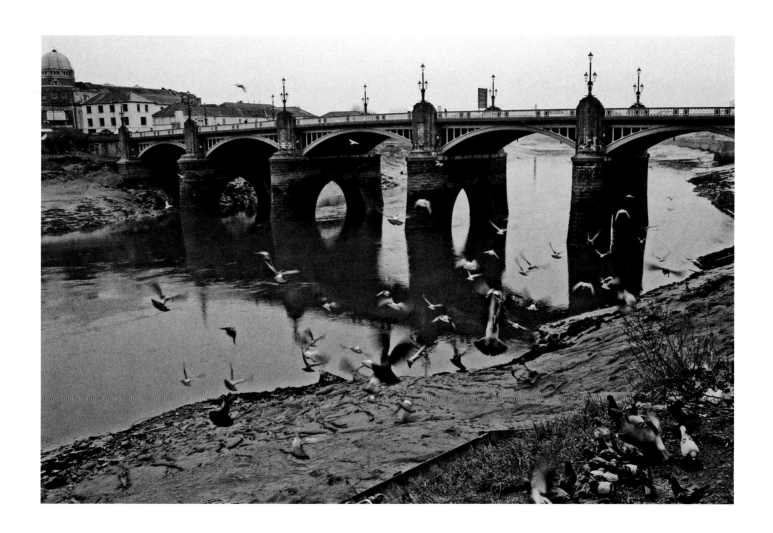

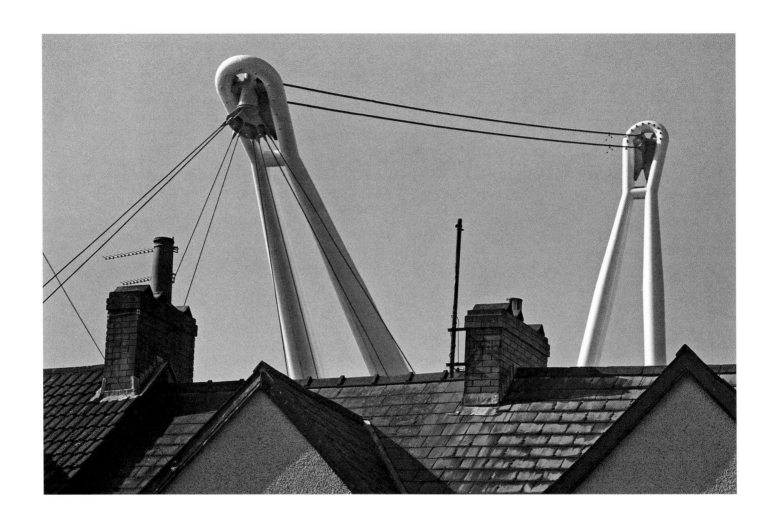

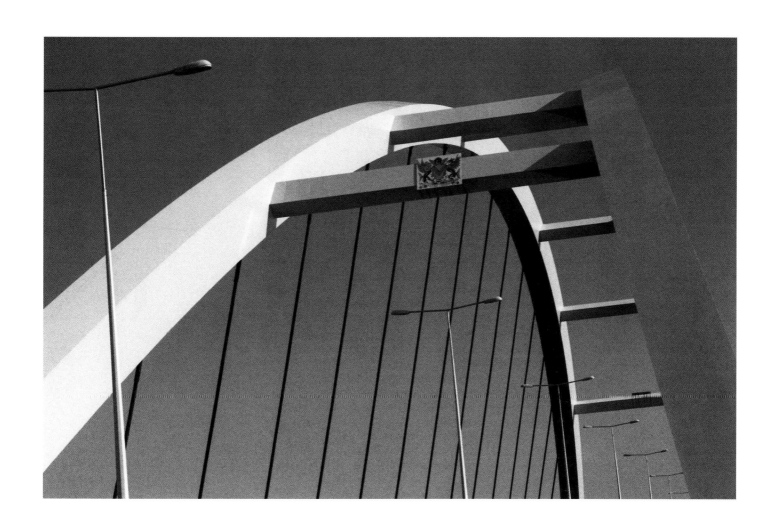

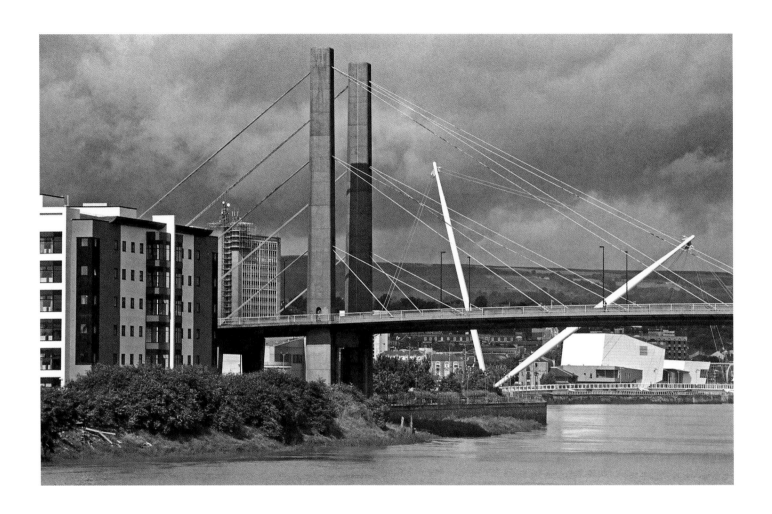

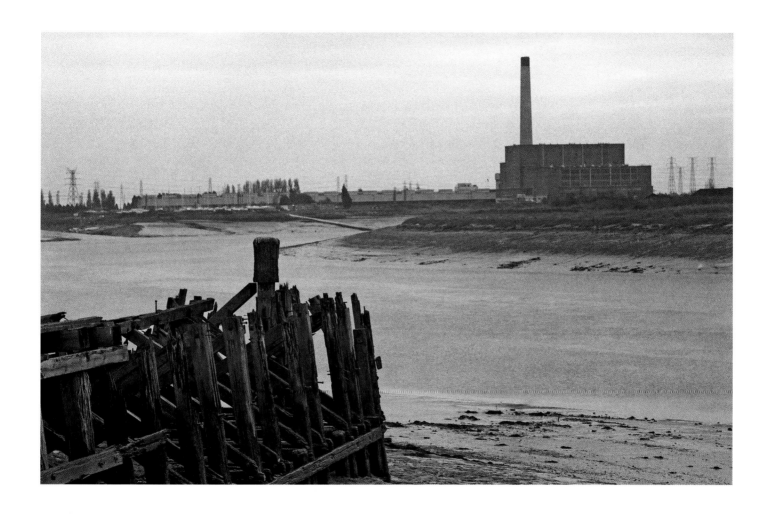

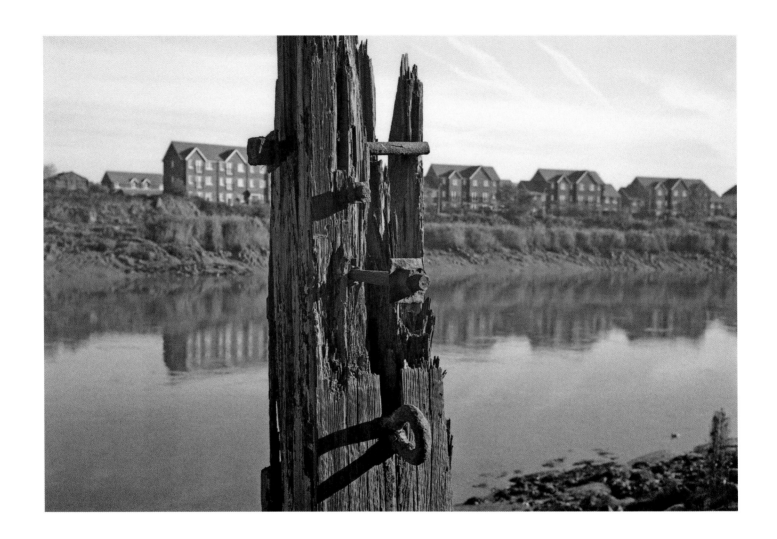

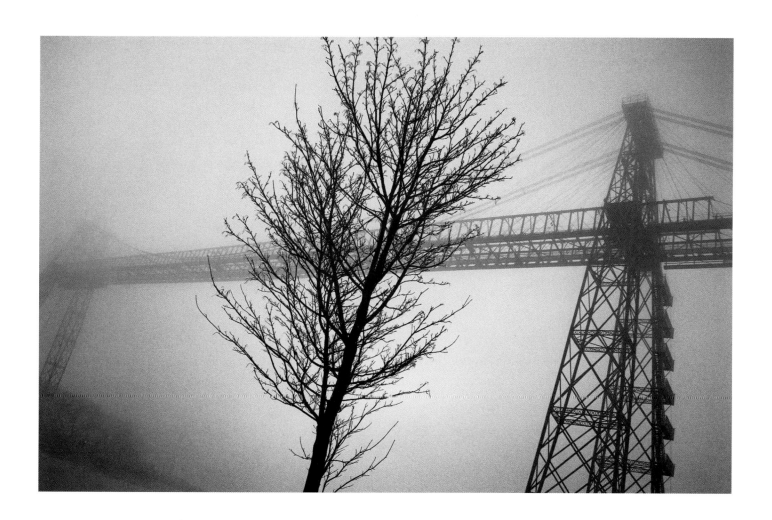

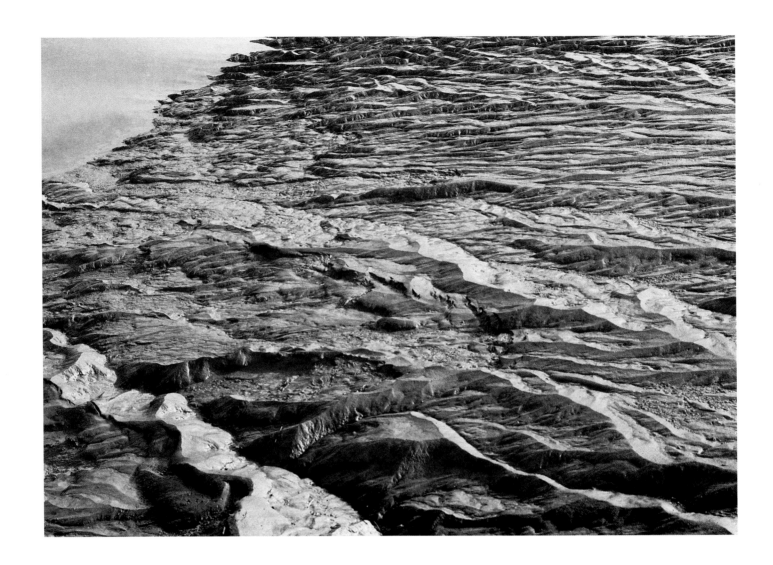

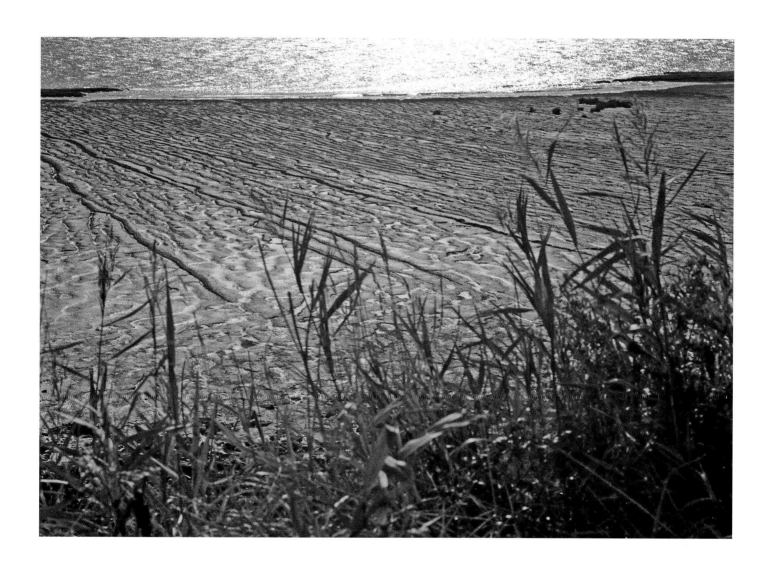

Captions

City People (1)

14. *Skinner Street, Queen's Jubilee.* A proud mother adds the final touches to her daughter's toilette for the Queen's visit to Newport on 13 June 2002 in recognition of it's newly conferred city status.

15. *Upper Dock Street.* The younger generation wait in cheerful mood for the Queen to arrive in Newport city centre.

16. *Market Square.* Coiffed, made-up and dressed in their finery, these young ladies are happy to be part of city life on the weekend.

17. *Westgate Square, construction workers on their lunch break.* A familiar sight given the amount of new construction taking place in the city centre.

18. *Commercial Street, newspaper vendor.* Lady vendors in their kiosks were a familiar feature of the city centre but seem to have been dispensed with by the new Millennium.

19. *Entrance to John Frost Square, Frankie, street singer.* He was one of Newport's 'characters' immediately recognized by his operatic voice and arias sung in the echoing arcade next to John Frost Square.

20. *GPF Gallery, George Street.* Mrs. Janet Martin, proprietress, has been serving the arts community of Newport since the 1980s. A fine art gallery was added to her framing works in the mid-1990s and more recently she converted stables behind the gallery into new studio facilities. She has just turned an Edwardian church near the gallery into a multi-purpose arts venue; Barnabas Art House opened in July 2009.

21. *Hera Art, Newport Market/Charles Street.* Hilda Smith, who founded her art centre in Charles Street in the 1990s is seen displaying her work at 'Art in the Market' in 2001.

22. *Traces, Upper Dock Street.* A well-known independent shopkeeper, Mr. Roger Trace retired at the end of 2007 after 52 years of trading, having established his home decorating business in 1955.

23. *Sullivan's Cycle Mart, Commercial Road.* Margaret Sullivan, proprietress. When her father, still working in the shop after 47 years died at the age of 82 in 2007, Margaret took over the business.

24. *Newport Market, Fruit and Vegetable Stall.* Such vendors were typical of those in Newport Market's upstairs gallery stalls before their refurbishment in 2002/2003.

25. *Clare Food Store, Commercial Road.* This Asian supermarket supplies all the ingredients for Indian cuisine to restaurants and takeaways in the Newport area as well as to the local community.

26. *Café, Newport Market Balcony.* Traditional stalls and businesses were moved from the upstairs area, some relocating downstairs on the main floor, when refurbishment took place. This one called it a day, however.

27. *Newport Market, Market Attendant Carole Ellis: keeper of the ladies' loo.* Carole won Attendant of the Year Award for Wales and England in 2005/06. Thanks to her the ladies' convenience maintains its 5-star rating.

28. *Pill Saturday Market.* Shoppers display their purchases at the open air market in Pill. This popular, longstanding facility had to relocate from its Cattle Market site in 2008 to make way for a supermarket.

29. *Commercial Road.* Residents like this older Muslim gentleman, in playful mood, give the Commercial Road area a congenial, cosmopolitan feel.

30. *Wednesday Cattle Market.* Livestock buyers from Wales and the west of England attended the weekly cattle and sheep auctions for over a century and a half before it was sold off for redevelopment in 2008.

31. *Marlborough Road.* The council cleaner does his rounds. Damaged in August 2007 in one of Newport's worst fires, a row of houses in awaits rebuilding.

32. *Premiership Ltd., Lower Dock Street.* These entrepreneurial high-fliers operate the only ship brokerage firm still in the city, whereas a century ago Dock Street was at the heart of Newport's coal export-based economy. They stand before the preserved doors from the offices of Reardon Smith Lines, a once-famous Cardiff shipping company.

33. *Phillips' Gents Outfitters, Market Arcade.* Tony Kibblewhite, the archetypal, dapper, traditional shop owner, ran this long-established Newport business for 36 years before retiring in 2001.

34. *Former Simpson's Bar, High Street.* Two pubgoers enjoy a chat and a smoke sometime before the smoking ban was introduced in July 2007.

35. *Irish Club, Commercial Road.* The club is an enclave of Irish culture as well as a popular nightspot the pleasures of which these ladies are enjoying on St. Patrick's Day.

36. *Hen Party, High Street.* The many clubs and pubs in the city centre make this a familiar scene on the weekend.

37. *Le Pub, Caxton Place.* Newport boasts a large number of live music venues, and was once dubbed 'the new Seattle'.

38. *Rodney Parade Rugby Stadium, Rodney Parade.* Newport Gwent Dragons rugby fan. Imaginative headgear and enthusiasm in large

amounts help to boost the cause of the Newport Gwent Dragons, one of four professional regional rugby sides in Wales. Plans are afoot for a new 15,000 seat facility on the Rodney Parade site.

39. *Newport Stadium, Spytty Park.* Fans cheer their Newport County football side in the last FAW Cup Final ever to be played in Wales, in March 2008. Newport County beat Llanelli Town 1-0.

40. *Newport Velodrome, Spytty Park.* Cyclists train on the state-of-the-art track opened in November 2003. The facility played a vital part in the preparations of the British cycling team that won 14 medals at the Beijing Olympics 2008.

41. *Celtic Manor Hotel and Resort, 2010 Golf Course.* Marshal at the 2008 Welsh Open. Not quite as forbidding as he looks, he holds up his sign when golfers are teeing off and putting on the greens. Newport is the host city for the prestigious Ryder Cup in 2010.

42. *Caerleon Amphitheatre.* Isca Morrismen, a Newport institution since 1976, performing the first dance of the year on May 1st at sunrise.

Landmarks and Features

44. *Westgate Hotel, Westgate Square.* The site of the Chartist Riots of 1839 that put Newport into the history books. The present Victorian hotel opened in 1887. Five stories high, it was built during Newport's 'belle époque' when prosperity and exuberance were evident in the town's architecture. A fitting place for the 'New City' banner.

45. *High Street/ Commercial Street Buildings.* Victorian and Edwardian architecture abounds in the city centre and these are but two examples of Newport's largely intact but under-appreciated facades.

46. *Tredegar House, Edney Gates.* Newport's finest residential landmark is one of the best examples of a seventeenth century Charles II mansion in Britain. For over five hundred years it was home to that most extravagant of Welsh families, the Morgans – later Lords Tredegar – until they left in 1951. The gates were made in 1714-18 for Henry Morgan, a buccaneer and one of the most colourful members of the Morgan family.

47. *Newport Cathedral: Woolos, King and Confessor.* Designated the Cathedral for the Archdiocese in 1949, it boasts a Norman arch and nave dating from 1140-60 and a modern east end constructed in 1960. Much of the cathedral's fabric is due for urgent rescue and repair work. An appeal was launched in 2007.

48. *Riverfront Theatre and Arts Centre, Kingsway.* Opened in 2005 it provides the city with first-rate professional theatre, music and art exhibitions while catering for the local arts scene. In contrast to Newport's Victorian architecture, it is a futuristic flagship building that heralds Newport's entrance into the twenty-first century and a new 'Left Bank' District or Cultural Quarter for arts/culture/education.

49. *Cenotaph and Newport City Church, Clarence Place.* Newport's war memorial, an important historical landmark off the city centre just east of the Town Bridge, was erected in 1923. The Newport City Church, among the popular new breed of evangelistic places of worship in the city, was originally the art-deco styled Odeon Cinema.

50. *Market Tower, Newport Indoor Market.* Probably Newport's finest Victorian structure, the market opened in 1889. It has served continuously as Newport's provisions market for 120 years and has recently seen significant restyling of its interior, particularly the balcony level.

51. *Newport Cattle Market.* Façade and railings. Opened in 1844 and presently Grade II listed, a huge amount of ships' ballast was required to raise the level of the marshy land of Pillgwenlly on which the market was placed. The market closed in February 2009 after 165 years of trading to make way for a new supermarket.

52. *Scard Street, Baneswell.* Its nineteenth century terraces stand conveniently adjacent to the city centre. This is a Newport residential area of much character and some interesting quirks, such as this modern-day ornamental 'Baneswell Lion'.

53. *Monnow Way, Bettws.* Well-maintained council housing in attractive settings makes Newport's estates desirable places to live and promotes a strong sense of community.

54. *Newport Public Art, 'In the Nick of Time'.* Formerly situated in John Frost Square, the clock was originally made for the Garden Festival at Ebbw Vale in 1992. It will be relocated once the remodelling of the square has taken place. A fascinating working sculpture that opens and closes when the hour strikes.

55. *Newport Public Art, 'The Wave'.* Situated near the Town Bridge and Newport Castle, it commemorates Newport's maritime and steel industries. Another example of Newport's large-scale public artworks.

56. *Riverfront Arts Centre, Main Entrance.* Its abstract, modern forms have aroused strong feeling for and against, but its contribution to Newport's cultural life is most significant.

57. *Newport Market, Stained Glass Window.* With its motifs reflecting the market's activity as well as aspects of the city of Newport, it is said to be the largest stained-glass window in Wales. It was designed by artist

Catrin Jones and completed in July 2003.

58. *Ebbw Vale Wharf, site of Newport University Campus.* Benches along the Riverside Walk mark the old wharves named after the industrial and coal mining towns of the Gwent Valleys, Ebbw Vale being one of several. These sites are being put to use as Newport University's new riverside campus, due for completion in 2010. It will house the School of Art, Media and Design, the Newport Business School, and cater for 3,000 students.

59. *Newport City Footbridge under construction, 2006.* The new crossing provides a pedestrian/cycle link between the Maindee/Victoria area and the city centre. Its uprights were hoisted into position by the UK's largest crane in May 2006 and the bridge was opened on 12 September, exactly 100 years after the opening of Newport's famous Transporter Bridge.

60. *Artwork, Newport Transport Bus.* Imaginative designs promoting Newport's renewal such as this are used on buses.

61. *Ryder Cup Banner at the Welsh Open 2008,* to promote Newport's standing as host city.

62. *Old Green Crossing at Night, near the River Usk and Town Bridge.* Dating from the 1960s, it brings together the city's busiest streets.

63. *Alexandra Road, Transporter Bridge at Night.* Day or night, the Transporter Bridge, dramatically lit after dark, is Newport's most recognisable maritime landmark.

64. *Twm Barlwm.* Newport's most recognisable natural feature dominates the view to the northwest of the city. The 'pimple' to the left of centre at the crest of the ridge is said to mark the remains of an Iron Age hillfort.

65. *Newport Civic Centre and surrounding landscape.* Started before World War II but not completed until after it, the Civic Centre and its impressive clock tower do not look out of place in the twenty-first century city. Newport's setting as a city is unrivalled in Wales.

66. *Celtic Springs Business Park.* Twenty-first century business parks on the city outskirts now provide space and accommodation for the new service industries that help drive Newport's economy forward.

City People (2)

68. *Alice Street, Queen's Jubilee.* Neighbourhood street parties no doubt evoke war-time memories for older Newportonians but such festivities came to the fore again when the Queen visited Newport in June 2002 to celebrate it's City status.

69. *Bridge Street, Queen's Jubilee.* These members of the younger set seem not too bothered by Her Majesty's visit.

70. *Austin Friars, The Bell Carrier.* The bronze bull by sculptor Sebastian Boyesen has stood in Austin Friars since 1996, attracting the attention of folk who walk past it or who choose to take a break on one of the benches placed near it. The figure was inspired by the legend of Gwynllyw's (St. Woolos) conversion to Christianity.

71. *Chartist Passage nr. John Frost Square.* A participant in the 1839 Chartist March on Newport seems bemused by the devices of the twenty-first century. Amid much public protest the 200,000 tile mosaic, created by Kenneth Budd and in place since 1978, is scheduled for demolition to make way for a new shopping/leisure development. Assurances have been given by developers that an exact replica will be rebuilt in a new location.

72. *Bellevue Park Bandstand.* Bellevue Park pavilion, bandstand and conservatories have been restored to their former glory with Heritage Lottery funding. Official reopening took place in September 2006.

73. *Market Square.* By the Dock Street entrance to the market, the recently enhanced square attracts creatures of both the two-winged and two-legged varieties to its stylish, user-friendly seating.

74. *Cattle Market, calf auction.* Scenes like this are now consigned to history. The last weekly auction took place on 25 February 2009.

75. *Cattle Market, cash buyers.* Purchases at the cattle market were obviously not transacted via high-tech means.

76. *Malpas Road, bus stop.* Twenty-first century bus shelters provide illumination, digital displays of bus times, maps of routes and, most noticeably, advertising of every kind to attract the attention of the bus user.

77. *Alway Youth Club and bus stop mural.* Newport is famous for its high-profile public artworks, but worthy of notice too are the increasing number of commissioned spray-painted murals in city neighbourhoods.

78. *Corporation Road.* Apparently the young cyclist isn't yet a member of the mobile phone generation.

79. *Chepstow Road, 'Tardis'.* This example of public art is one of Newport's oldest, dating from the 1970s if not before.

80. *Pill Carnival.* Newport's largest street celebration, funded and organized by local residents and businesses, has been held on August Bank Holiday since the early 1990s. Thousands of people turn out to watch the parade and floats, providing at the same time a telling glimpse of the ethnic diversity of the city's inhabitants.

81. *Clarence Street, funeral.* For less happy occasions, community participation again shows itself to be a potent force, on this occasion outside St. Michael's R.C. Church.

82. *Town Bridge, lady shopper.* Newport is not such a large city that the

centre is out of reach for those who shop in town and on foot for their everyday needs.

83. *Bridge Street, pedestrians.* Walking over the picturesque 'nuts and bolts' truss bridge near the railway station. Those using it perhaps do not appreciate that this structure is just as much a credit to the bridge-builder's art as the city's better-known bridges over the Usk.

84. *Kingsway.* Picking one's way through wire barriers has become a regular feature of walking through Newport during construction of the new shopping precinct.

85. *Newport Bus Station approach.* The Friars Walk project has involved the demolition of some well-known concrete eyesores near the bus station, especially multi-storey car parks. Unfortunately, as of 2009, the scheme has been held up because of the general economic downturn.

86. *River Usk, wharfside crane.* Not just in the city centre, but quietly, piece by piece, old structures in the docklands are being dismantled to be replaced by new facilities.

87. *River Usk, Newport Ship.* Archaeologists work to prepare the Newport Ship, c.1485, for preservation. The ship, which pre-dates Columbus' voyage to America, was discovered in 2002 during excavation for the foundations of the Riverfront Arts Centre. Its reconstructed remains will eventually be displayed in a permanent gallery there.

88. *Bellevue Park.* Sunday concert-goers enjoy the newly restored facilities in front of the bandstand.

89. *Celtic Manor Golf Course.* The 2008 Welsh Open was the first tournament to be played on the newly finished 2010 Course. so-called in anticipation of the Ryder Cup tournament.

90. *Beechwood Park.* A senior couple with their grand-daughter enjoy a walk in another of Newport's many green spaces. Newport has five public parks, Beechwood being the main one on the east side of the city in the Maindee area.

Industrial, Maritime and Riverscape

92. *Llanwern Steelworks viewed from Alway.* Largely demolished in 2005, it was the mainstay of the local economy since beginning production in 1961. In 2001, the iron and steel-making part was closed and its iconic blast furnaces and cooling towers, for four decades the most spectacular part of Newport's industrial landscape, were brought down. Half of the huge site is still in use but on the other half the creation a new village to include 4,000 houses with all amenities as well as a business

park is projected to proceed through to 2020.

93. *Imperial Park, bus stop outside the former LG Semiconductor Plant.* Completed in 1997 at huge cost, the factory was heralded as the lynch-pin of Newport's new industrial revolution after the loss of the city's heavy industrial base. Unfortunately the plant never entered production as the market for semiconductors and microchips collapsed soon after it was built. It is now awaiting conversion to a Data Centre.

94. *Mendalgief Road, Whitehead Steelworks sheds awaiting demolition in 2008.* Another of Newport's steelworks, this one devoted to rolling steel strip and galvanizing, which closed in 2006 when these services were moved to Llanwern Steelworks. Newport's authorities strongly support it as the location for a new regional and local hospital, as well as for new housing.

95. *Whitehead Steelworks, interior and detail during demolition.* Relics of a now bygone age, but in this case preserved for posterity by a Newport-based photographic collective who used them in a multimedia installation 'Ghosts in Armour'.

96. *Former Newport Technical Institute/Art College awaiting conversion into flats.* The building dates from 1910 when it opened as the Newport Technical Institute. In 1958 it became the Newport College of Art, but closed in 1985. University art studies will be brought back to the city in 2010, however, when the new riverside campus is completed.

97. *Alexandra Road, Waterloo Hotel and Bistro.* Both the interior and the exterior of this fine Victorian building, apparently once the busiest hotel/drinking saloon in Wales, have been restored and the Waterloo re-opened its doors as a fine restaurant and hotel once again in 2007.

98. *Commercial Road, hairdressers.* C. George's former frontage is eclipsed by new advertising at an illuminated bus stop.

99. *Newport Indoor Market Balcony.* Traders' tables and wire mannequin. These 'ghosts' of former trade in the market's upstairs gallery were removed to make way for the present open-plan activity space, café area and redesigned stalls/small-business units.

100. *Commercial Road old works.* Newport Hosiery gave way to new housing development in the1990s.

101. *Commercial Road shopfront.* B&L, a traditional workmen's clothing supplier, is still in business as of 2009.

102. *Alexandra Road broken window frame.* It belonged to the former Tredegar Dry Dock buildings demolished long after ship repair was consigned to the past.

103. *Church Street scrap dealer's.* Mono Metals took the street's name

seriously and placed a prominent cross to grace the top of its perimeter wall. The wall was once that of the Tredegar Dry Dock.

104. *Commercial Road, disused chapel and cinema.* When the former Wesleyan Methodist Chapel closed as a place of worship, it finished its days as a furniture warehouse. The disused cinema next door became the Handiland DIY store.

105. *Beechwood House.* One of the city's finest Victorian houses, it has recently been restored as enterprise units for small businesses, a café, and community rooms for the public.

106. *Alexandra Road, Waterloo Hotel and Bistro.* The window indicates a segregated arrangement of the interior typical of the days when sea-captains and sailors alike used this grand watering-hole, but without rubbing shoulders.

107. *Lower Dock Street/George Street,* window detail of former shipping offices which were numerous in the area a century ago.

108. *Old Town Dock, maltings.* Phillips and Sons, a once-prominent Newport brewery located in Dock Street, had its maltings on the River Usk next to the entrance of the Old Town Dock. At present the building awaits restoration as part of the redevelopment of the area.

109. *Alexandra Road, former Tredegar Dry Dock* buildings date from 1906. After closure the dry dock was used as a car breaker's yard, then a DIY warehouse before finally being destroyed by fire in 2003.

110. *Newport Docks, tugboat and ship's stern.* The *MV Doulos,* an occasional visitor to Newport Docks, is at berth during a visit in the 1990s.

111. *Newport Docks,* freighter departing the South Dock assisted by the tug *Gwentgarth.*

112. *River Usk, daytrippers on P.S. Waverley.* Even in the twenty-first century it is possible to take the pleasure steamer from Newport during the summer excursion season.

113. *River Usk.* Waverley paddle steamer departing Blaina Wharf. This has now been replaced by the newly upgraded facility, Church Street Wharf, near the Transporter Bridge.

114. *River Usk at high tide 2001.* The Wave is in place, but many new additions have appeared in recent years. An industrial/maritime facility up until the late twentieth century the river has now become the focal point for Newport's twenty-first century regeneration.

115. *River Usk at low tide, Town Bridge.* This has been the site of Newport's busiest river crossing since Roman times. The present bridge was built in 1927 and replaced a nineteenth century stone bridge.

116. *Colne Street, Newport City Footbridge, supports and rooftops.* A century separates the architectural styles and materials of the two structures. Looming above the traditional terraced houses of Colne Street on the east bank of the Usk, the tallest support is 65m (200ft) tall and provides an arresting example of the city's regeneration.

117. *Southern Distributor Road (SDR) Bridge (2004).* The 'jewel in the crown' of the SDR system which diverts heavy traffic from the city centre and residential neighbourhoods in south Newport. It is of the 'bowstring arch' design, adding further variety to Newport's collection of river crossings.

118. *George Street Bridge, and new construction.* Immediately to the left of the bridge is recently built student accommodation, already completed (2008) in anticipation of the new riverside university campus. In the distance, the steel diagonals of Newport City Footbridge (2006) contrast with the concrete uprights of the George Street Bridge (1964). The area near the west end of the old bridge, a former industrial area, has now been redeveloped as an office district.

119. *River Usk derelict wharf and Uskmouth 'B' Power Station.* The coal-fired power station produces Newport's electricity and used to stand next to a larger plant, Uskmouth 'A', demolished in 2002. The building of a new gas-fired power station on the old site has been approved as has an eco-friendly, zero carbon footprint station in Newport Docks.

120. *River Usk old wharf timbers and new housing (2007).* Such ancient maritime relics will probably removed (or could be incorporated?) as riverside landscaping continues in coming years. Before the construction of Newport's first dock in 1842, such wharves, a few still in existence today, were the main facility for the loading of coal and other commodities onto ships. Until the 1980s the Usk was still an industrial and maritime facility, much of it derelict, but it has now become a residential one with several new housing projects on the East bank.

121. *Transporter Bridge (1906) on a foggy morning (2006).* The bridge was designed to overcome the problem of crossing the Usk while allowing tall-masted sailing ships to sail beneath. The boom/centre span is 177 feet above the Usk at high tide. It is one of only eight remaining in the world.

122. *River Usk, mud patterns at low tide.* An ever-changing, ever-intriguing feature of Newport's river.

123. *Newport Wetlands Reserve, foreshore at low tide.* Here Newport meets the sea and gives credence to the words of its Latin motto 'Terra marique', 'By land and sea'. The Gwent Levels Wetland Reserve was established in 2000 to compensate for the loss of bird habitat 10 miles away in Cardiff Bay, a consequence of the building of the Cardiff Barrage.